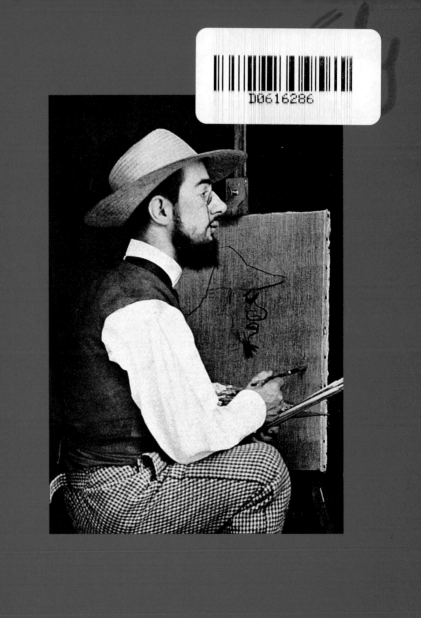

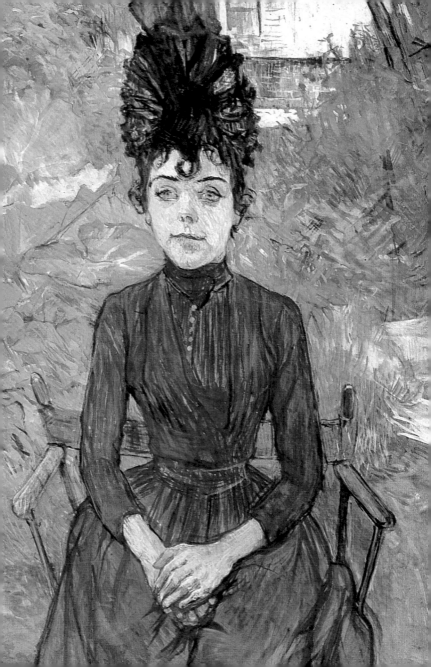

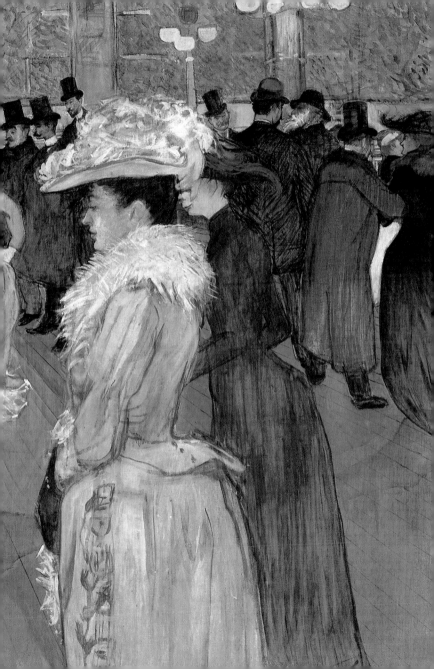

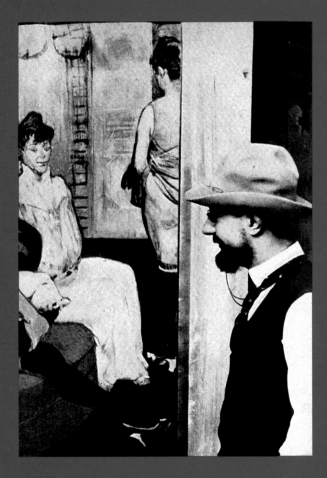

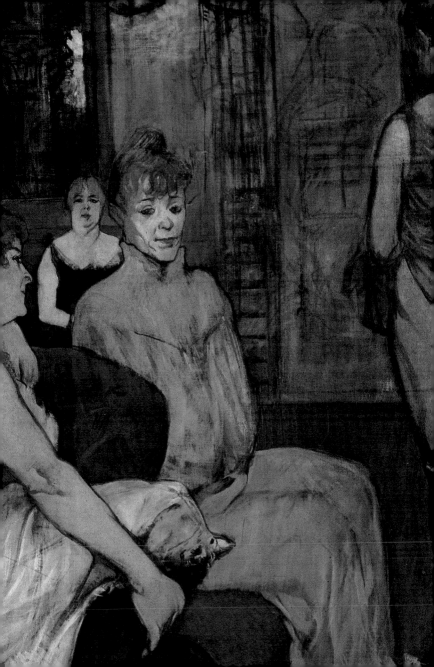

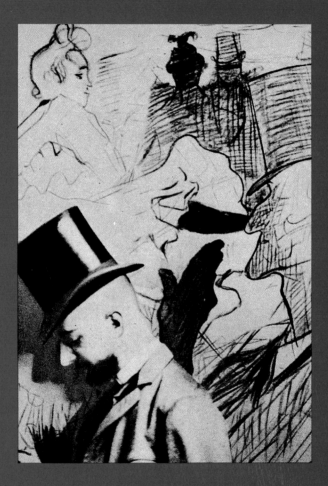

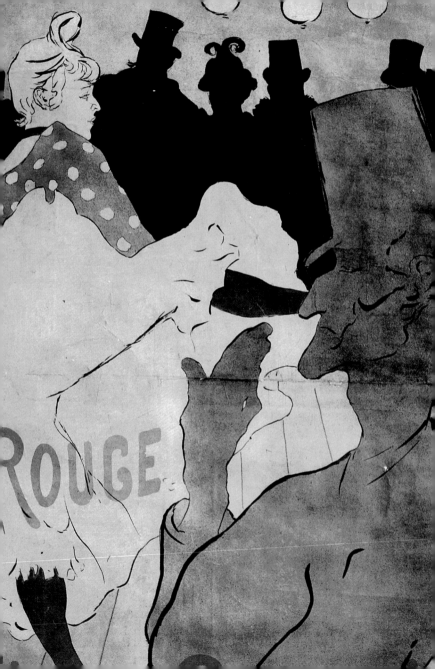

CONTENTS

TOULOUSE-LAUTREC
SCENES OF THE NIGHT

Claire and José Frèches

DISCOVERIES

HARRY N. ABRAMS, INC., PUBLISHERS

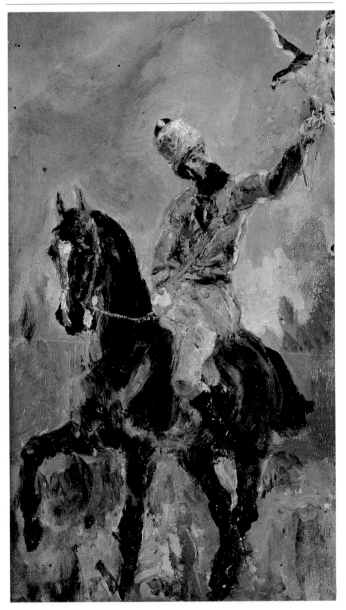

"His bone structure was so fragile that he suffered two fractures within a year of each other, first his left and then his right thigh bone, after minor falls," wrote Comte Alphonse, Henri's father. These accidents decisively affected the childhood and upbringing of Henri de Toulouse-Lautrec, who was born into a noble family of Provence. He was drawn at an early age to drawing and painting.

CHAPTER I
YOUTH

Count Alphonse de Toulouse-Lautrec (opposite) was an eccentric dilettante with a passion for hunting and falconry. This portrait was painted in 1881 by his son Henri when he was seventeen years old.

The photograph on the right shows Henri aged about three. Although he shared some of his father's tastes, there was no real empathy between them.

In the Shadow of the Cathedral

It was on 24 November 1864, in the elegant family home, the Château du Bosc, a few steps from the great redbrick cathedral of Sainte Cécile at Albi, that Henri-Marie-Raymond de Toulouse-Lautrec-Monfa was born to Count Alphonse de Toulouse-Lautrec-Monfa (1838–1913) and his wife, Countess Adèle, née Tapié de Céleyran (1841–1930). The boy's parents were first cousins. The Lautrecs and the Tapiés had intermarried on numerous occasions—not without adverse genetic effects, in the

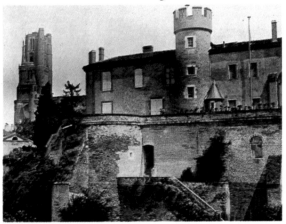

opinion of some of the doctors consulted about Henri, who was sickly and weak from birth. He was a direct descendant of the famous counts of Toulouse, who ruled the Languedoc region of France from 750 to 1271. One of his ancestors, Count Baudouin, had in 1196 married Alix, Viscountess de Lautrec and heiress to the lordships of Monfa. On that date Lautrec and Monfa were added to the family name Toulouse.

Born into a privileged circle with ample leisure time and a taste for field sports, Henri was handicapped by the physical injury he suffered in childhood. His father, with whom he had a strange relationship founded on mutual incomprehension, had a passion for hunting and falconry. An eccentric, solitary aristocrat, prone to unconventional behavior, the count used to spend time

The Château du Bosc (left), on the Rue de l'Ecole-Mage, is one of the oldest dwellings in Albi. Standing within the ramparts of the old town, flanked by two towers, it was built by Pierre du Bosc in the 12th century. When Countess Adèle went there to prepare for the birth of her child, it was inhabited by her maiden aunts, the Imbert du Bosc ladies. Henri was born there on a stormy November night in 1864.

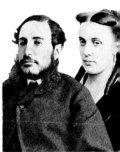

Henri's parents (above) were cousins, and utterly opposed in character. Alphonse, a former officer in the military, loved circuses, kites, and fancy dress. "Whenever papa is there, you are sure not to be the most interesting person present." Adèle was quiet, cultivated, religious. "A saintly woman," remarked Henri, "but she could not resist the cavalry's red trousers!"

A sickly adolescent, Henri showed early artistic talent. His first subjects were a faithful reflection of his father's interests: dogs, horses, horse-drawn carriages, and falcons. His handling of oil paints in this painting of a peregrine falcon (1880) is astonishing for his age—sixteen. He captures the lofty cruelty of this emblematic bird of prey, so well loved by his father.

in a studio in Paris, doing a little sculpture and drawing. On 1 January 1876, when his son Henri was eleven, he gave him a small handbook on falconry inscribed with the following dedication: "Remember, my son, that the only healthy way to live is out in the open air and daylight, that everything deprived of freedom loses its identity and soon dies.... This little book on falconry will teach you to appreciate the life of the open fields; and should you one day experience the bitterness of life, first horses, then hounds and falcons will be precious companions and help you to forget things a little."

This sketch of Henri is by his father, an amateur painter and draftsman.

Though he had a great love of the country, Lautrec painted landscapes only in early youth. His later work features nature solely as background. In *Window Overlooking the Garden of the Château de Céleyran* (left), a view from his family's summer residence painted in 1880, Lautrec was clearly influenced by the Impressionists.

Fractures

Henri, who fractured his left thigh bone falling off a chair in the Château du Bosc on 30 May 1878, was destined never to enjoy the outdoor life, the world of riding, hunting, and sport. He was then thirteen years old, but looked ten. The following year he broke his

right thigh bone at the spa of Barèges in the Pyrenees Mountains. From then on he was an invalid with atrophied legs who was increasingly rejected by his father. The rest of his childhood he divided between the family châteaus at Le Bosc, in the department of Tarn, and Céleyran, near Narbonne, in the department of Aude, and the spas of Barèges, Amélie-les-Bains, and Lamalou.

Lautrec's mother was quick to perceive that her son would be a painter. A caring, reserved, and cultivated woman, she was worried by his vocation, yet she still supported him financially throughout his life.

Lautrec's drawing of his father, *Four-in-hand* (opposite), is from *The Book of Zigzags* and is inscribed "Nice 1880." It is probably the basis of his painting of *Alphonse de Toulouse-Lautrec Driving His Mail-coach* (1881, left), which bears the inscription "Souvenir of the Promenade des Anglais" (in Nice)—though the greenery in the background and the cloud of dust are more suggestive of a wild race in the country. Lautrec said he owed the liveliness of the picture to "the colorful scenes" of which he was by this time no more than "an immobile spectator."

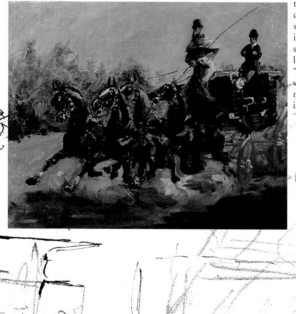

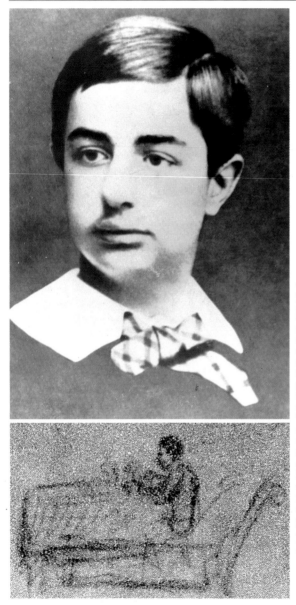

A number of scientific theories have been advanced to explain Lautrec's physical infirmities. Some physicians diagnosed dwarfism, because of his atrophied legs, others spoke of osteoporosis or a tumor of the thyroid gland. There was also mention of coxalgia, a disease of the hip joint. The various diagnoses all reached the same broad conclusion: The extreme fragility of the boy's bone structure was either a hereditary condition or an ailment difficult to identify. The frequent intermarriages among his forebears could well have had something to do with it.

Lautrec had always had trouble with his legs. As early as March 1877 he wrote to his grandmother: "I have more free time just now because Mama has taken me out of the professor's classes so they can give me the electric brush treatment that once cured my Uncle Charles. I am awfully tired of limping with my left foot now that the right one is cured." Then came the accidents, which Lautrec attributed only to his own clumsiness.

"I fell from a low chair onto the floor and I broke my left thigh," he wrote to his friend Charles Castelbon on 30 May 1878.

"The second fracture," wrote his father, "was the result of a scarcely more serious fall, when he was out walking with his mother; he rolled to the bottom of a dry gully no more than a meter or a meter and a half deep."

Opposite: A photograph of Henri at the time of his second fall, in 1879 (above left); Henri's sketch of the surgeon who treated his fracture (above right) and a self-portrait (below).

Portrait by René Princeteau of Lautrec (left) aged about nineteen.

Lautrec was always close to his mother, and the two of them kept up a regular correspondence that reveals a great mutual trust and sympathy. One of the painter's first significant works, dating from 1883, shows a dejected Countess Adèle de Toulouse-Lautrec, soon after her separation from her husband, sitting in the dining room with a cup of tea in front of her. Lautrec was already using a palette of very light colors that he applied to the canvas with vibrant brush strokes, in the manner of Edouard Manet

(1832–83) or Berthe Morisot (1841–95), though he had not yet had any lessons.

A Precocious Talent

Lautrec began drawing at a young age. In 1881 he covered the pages of little exercise books, such as *The Book of Zigzags,* dedicated to "my cousin Madeleine Tapié, with the worthy aim of distracting her a little from the lessons of Madame Vergnettes" (Nice), and dashed off the twenty-three pen-and-ink drawings for *Cocotte,* early indications of his talents as a caricaturist. (*Cocotte* is a short tale about a priest and a horse. It was illustrated in a hydropathic spa where Lautrec was obliged by his ill health to spend a considerable amount of time. The text was written by his friend Etienne Devismes.)

After failing a first attempt at his *baccalauréat* exam in Paris in the spring of 1881, he passed the exam in November, at Toulouse. He then traveled back to the capital to show his drawings to a friend of his father's, René Princeteau (1839–1914), a painter of genre scenes and horses who was a deaf-mute. Princeteau was working

Lautrec was always drawing in his exercise books. In 1881 he illustrated *Cocotte,* a story written by his friend Etienne Devismes. His humorous drawings (above left) trace the sad life of a horse named Cocotte who belongs to a priest.

at the time in a studio at 233 Rue du Faubourg-Saint-Honoré, a street frequented by painters specializing in horse-racing scenes and views of the Bois de Boulogne, among them John Lewis Brown (1829–90). and Jean-Louis Forain (1852–1931). Despite his father's reservations, but with the support of his (paternal) Uncle Charles, Lautrec decided to pursue his artistic calling and began to study with Princeteau. Princeteau introduced the young man to the painter Léon Bonnat

"At fourteen, in 1878, he copied my studies and did a portrait of me that made me shiver," wrote Princeteau of the boy he called his "studio nursling." Lautrec painted the above portrait of his teacher around 1881.

Nothing could interfere with Lautrec's almost daily contact with his mother; when they could not see each other, they wrote. His 1883 portrait of the Countess Adèle (left) conveys the sadness of this virtuous woman, who was at this time separated from her husband and suffering the death of her second child.

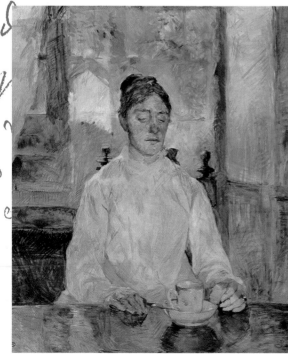

(1833–1922), whose studio Lautrec joined in March 1882 as an apprentice, following the usual practice of every would-be artist of that era.

Studying Under Bonnat and Cormon

Bonnat's studio, along with those of Jean-Léon Gérôme (1824–1904) and Gustave Moreau (1826–98), was one of

the most highly thought of at the time. These studios were, in essence, art schools, where well-known masters taught students who dreamed of winning the gold medal at the Salon or the Prix de Rome. Lautrec's original intention had been to work under the portrait painter Charles-Emile-Auguste Carolus-

Duran (1838–1917), but Princeteau directed him instead to the studio of Bonnat, an old and prestigious master decorated by the French government, and the embodiment of everything in art that Lautrec later came to detest. (After Lautrec's death Bonnat did everything in his power to stop his former pupil's work being admitted to the national collections.) Bonnat was unsparing in his criticism and would say to the young Lautrec: "Your painting is not bad, it's rather stylish, but your drawing is frankly atrocious."

In September 1882 Bonnat was appointed professor at the Ecole des Beaux-Arts. He closed his studio, and Lautrec moved to one at 104 Boulevard de Clichy that had been recently opened by Fernand Cormon (1845–1924) at the express request of some of Bonnat's pupils. Cormon was an established history painter who specialized in antique and biblical subjects. His vast canvas *Cain Fleeing with His Family* was already prominently displayed at the Musée du Luxembourg. Other pupils at Cormon's studio

In his portrait *Young Routy at Céleyran* (c. 1883, above left), depicting a farm worker on the Céleyran estates, Lautrec is anticipating a letter he wrote to his friend Maurice Joyant in 1890: "The landscape is and should only be secondary, the pure landscape painter is but a brute. Landscape should only be a way of conveying the character of the model."

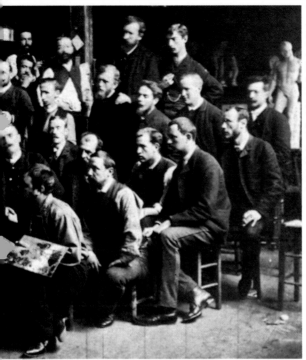

Fernand Cormon's great interests were antiquity and the ancient world. He was a brilliant technician and a benevolent teacher, always open to new ideas. In this 1885–6 photograph of Cormon's studio, Lautrec can be seen in the foreground, behind the teacher's easel. At Cormon's studio he practiced academic drawing, such as seen in the example below.

were the young Emile Bernard (1868–1941) and François Gauzi (1861–1933), also from Toulouse, whom Lautrec had first met at Bonnat's. Gauzi's *My Friend Toulouse-Lautrec* (1957) gives many details of Lautrec's life at this time and is an important biographical source.

It was during the years 1882–5 that Lautrec developed his own style. He had discovered avant-garde pictorial techniques and made a deliberate attempt to concentrate on them. Spending mornings at Cormon's studio and afternoons visiting galleries, he gradually came to understand the gulf that separated official art—as practiced by Bonnat, Cormon, Gérôme and Carolus-Duran—from the artistic movement acclaimed and practiced by the Impressionists, most notably after they first exhibited as a group in 1874 at the former studio of the French photographer Nadar. Lautrec decided to move with the times.

Parodying Puvis de Chavannes

At the 1884 Salon Pierre-Cécile Puvis de Chavannes (1824–98) exhibited *The Sacred Grove,* an immense painting that attracted impassioned comment. In two afternoons Lautrec produced a revised, "corrected" copy of Puvis' canvas, a painted version of the musical parodies then commonly found in popular comic operas. He exaggerated the static lines of his model and introduced areas of uniform color. In places he departed completely from the original: the muses of Eloquence and History disappear, and the muse of Tragedy is replaced by the Prodigal Son, seated opposite an easel on which two canvases are visible, clearly signed "Mac Kay" and "Meissonnier." Here and there he slipped in contemporary figures, himself in a provocative pose, and a Japanese man. Lautrec was already displaying the essence of his talent: an ability to extract what is best in pictorial tradition and handle it with a savage humor that exposes the yawning gap between the original and the "adaptation."

In the meantime Lautrec had moved to 19 bis Rue Fontaine with another pupil from the Cormon studio, the wealthy René Grenier.

Lautrec put a view of himself from behind—an insolent challenge to a respected master—in *Parody of the Sacred Grove* (1884, above and detail opposite). Below is his *Fat Maria* (or *Venus of Montmartre*) of the same year.

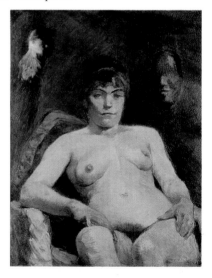

Edgar Degas also had a studio there. This geographical proximity accounts for the influence that the painter of dancers was to have on the painter from Albi, as much in his subjects—the famous *Mlle La La at the Cirque Fernando* (1879), hanging by her teeth from the top of a trapeze in the Cirque Fernando, where Lautrec also drew a female circus rider—as in the way he "framed" his subjects. Japanese prints were a recognizable influence, specifically the use of vanishing lines to give a sense of depth and the characteristic angularities that surround the forms and figures in the foreground—techniques in which Degas excelled and which were already appearing in Lautrec's work.

Lautrec admired Degas, and his work clearly showed the strong influence of Degas' painting *The Orchestra of the Opéra* (c. 1870), which Lautrec first saw at his cousins', the Dihaus. (The painting is a portrait of Désiré Dihau, bassoonist with the Paris Opéra orchestra.) Degas was driven to say to model Suzanne Valadon with a note of irritation: "He wears my clothes, but tailors them to his own measurements."

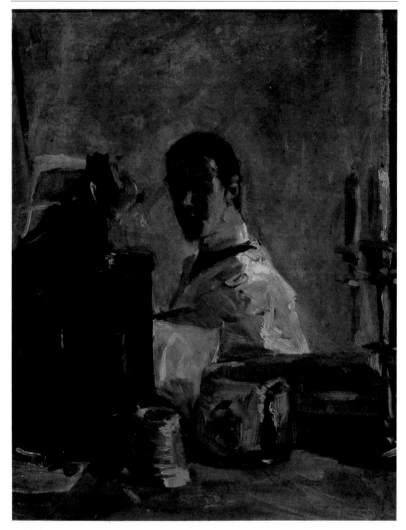

His Friends and His Modesty

Lautrec's group of friends at this period included the
painters Henri Rachou (1855–1944), René Grenier (1861–
1917), Adolphe Albert (1865–1928), François Gauzi, and

Opposite: Lautrec (far
left) with his friends
Anquetin (to his left) and
Grenier (center).

Louis Anquetin (1861–1932). He began to discover the charms and pleasures of Paris's social melting-pot and the red-light districts off the boulevards of Montmartre.

Lautrec was very modest about his work as an artist and for six years persevered with his apprenticeship under Cormon, whom he described as the "ugliest and thinnest man in Paris." To his grandmother he wrote in circumspect terms: "I'm not in the process of regenerating French art at all, and I'm struggling with a hapless piece of paper that hasn't done a thing to me and on which, believe me, I'm not doing anything worthwhile."

This humility—or clear-sightedness—characterizes Lautrec's approach to his work. In complete contrast to an artist such as Picasso, he did not strive to place himself in a historical or aesthetic context but, more simply, to represent reality as he saw it. However, this way of deflecting any critical approach to his work can also be interpreted as a supreme affectation and a sign of immense pride.

In the autumn of 1885 Lautrec moved into Rachou's apartment behind the cemetery of Montmartre, in the heart of the area that he would paint and draw from then on.

Lautrec painted this self-portrait (1883, opposite) with his back to the light, in a Spanish-Dutch style brought into fashion by the painter and art critic Eugène Fromentin in his *Maîtres d'Autrefois* (1876). The accumulation of objects in the foreground increases the sense of distance between model and viewer and also points to the artifice in painting. The presence of the mirror, an essential tool of the self-portrait, is almost palpable, while Lautrec gives only a shadowy and evasive glimpse of himself.

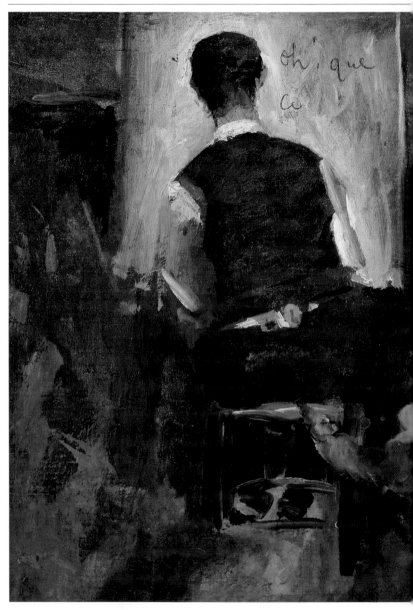

Toulouse-Lautrec's life was transformed by his discovery of Montmartre. He devoted his artistic talents to painting this unusual microcosm, with its intriguing blend of the vulgar and aristocratic, and his favorite haunts: the Moulin Rouge, the Moulin de la Galette, and the Mirliton. He was both a participant in and an acute observer of the life of the district.

CHAPTER II
DISCOVERING MONTMARTRE

This curious self-portrait (opposite) of Lautrec in his studio on Rue Tourlaque, turning his back on himself, defies logic. The Moulin de la Galette (right) dominated the hill of Montmartre. In the evenings people strolled in the garden, danced, and drank mulled wine.

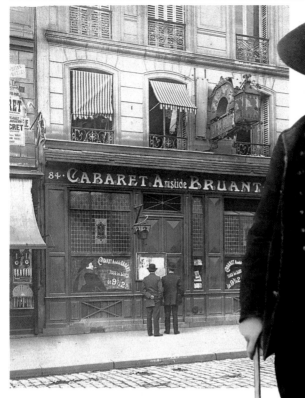

The painter from Albi plunged wholeheartedly into the life of Montmartre. He was soon consorting with the colorful inhabitants of this bastion of the Paris commune, whose character was aptly evoked by French writer Jules Vallès when he spoke of the "bleeding laughter of Montmartre." Between the Place Blanche, Pigalle, and the Butte—or hill—a whole disreputable world had evolved. Lautrec took to it like a duck to water.

"Every Evening I Go to the Bar to Work"

Lautrec made the acquaintance of Aristide Bruant, a singer and composer from the Gâtinais

who in July 1885 had opened a cabaret called the Mirliton on the site of the Chat Noir, a successful *cabaret-artistique* founded in 1882 by Rodolphe Salis, which had moved to larger premises. Its sign— "The Mirliton, the place to visit if you want to be insulted"—set the tone. Bruant's establishment fascinated Lautrec. It was there that he was first enraptured by the performances of disreputable women like Nini Peau de Chien ("Nini the Tart") and Rosa la Rouge ("Rosa the Red"), who sang in bantering and insolent tones to audiences made up of both the middle classes and the aristocracy, who were thrilled to find themselves in such low company. This was the world in which Lautrec found his inspiration, a world he was never to leave.

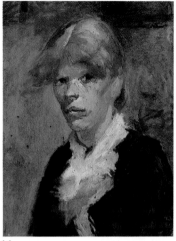

The *café-concerts* of the time took the place of the cinema today. The most famous halls in Paris—the Eldorado, the Alcazar, and the Scala—were situated on the Boulevard de Strasbourg. Encouraged by their success, others opened near the Opéra (the Eden), the Gare Saint-Lazare (the Pépinière), and at Montmartre (the Cigale). In addition to the large establishments there was a multitude of small places, such as the well-known Chat Noir, where for a modest sum, amidst clouds of tobacco, customers could hear songs that combined smut with wit. Bruant, an undisputed star of the *café-concert*, was the model for the character of Legras, the singer in the novel *Paris* by Emile Zola.

Footlights

Lautrec was quick to discover the effects of contemporary stage lighting, first put to painterly use by Degas. This very rudimentary lighting was provided by footlights, which cast the shadows of the actors upward, exaggerating their facial features to the point of caricature and emphasizing gestures and postures; silhouettes were made to stand out against the blank background.

This portrait of Aristide Bruant (opposite) is by the fashionable Parisian photographer Nadar. Beginning in 1885 Bruant's imposing figure presided over the famous cabaret at 84 Boulevard Rochechouart. "As you went into the Mirliton," recalled the painter Gauzi, "he challenged you, as if in greeting, with this reproach: 'Oh! là, là! What a face, what a mug. Oh! là, là! what a face he's got!' It was a ragging one tolerated with good humor." Gauzi also relates how Lautrec and his friend the painter Rachou met Carmen Gaudin (above), "a young girl in simple working clothes, but whose copper head of hair stopped Lautrec short."

Lautrec concentrated his attention on the lighting of his figures—whether stars of the *café-concerts* or the models for his portraits at the time, Suzanne Valadon, Jeanne Wenz, and the artist Emile Bernard. The latter, whom Lautrec had met at Cormon's studio, introduced him to *père* Tanguy, a collector of the paintings of Paul Cézanne and Vincent van Gogh.

In February 1886 Vincent van Gogh left Antwerp to join his brother Theo, who had opened a gallery in Paris. Van Gogh enrolled in Cormon's studio and there became friendly with Lautrec. In 1887 Lautrec completed a pastel portrait of the famous Dutch painter.

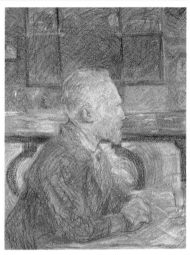

The *café-concerts* provided Lautrec with numerous subjects for paintings, including *The Song of the Louis XIII Chair at Aristide Bruant's Cabaret* and *The Quadrille of the Louis XIII Chair at the Elysée-Montmartre*, which was used for the cover of the December 1886 issue of cabaret-owner Bruant's magazine *Le Mirliton*. Another artist who contributed to this publication was Théophile-Alexandre Steinlen (1859–1923), whose rendering of street life, more tragic in its vision than Lautrec's, won him great renown.

This profile portrait of Van Gogh in iridescent pastel tones was painted by Lautrec in 1887 at the Café du Tambourin, according to Emile Bernard, whose portrait Lautrec also painted (1885, opposite).

From the ceiling of the Mirliton, Bruant had hung, as a lucky token, a Louis XIII–style chair left behind by the former owner. He wrote a song on the subject, which inspired Lautrec's painting *The Song of the Louis XIII Chair at Aristide Bruant's Cabaret* (1886, left). Bruant dominates the scene, in the background of which one can identify the poet Roinard, Louis Anquetin, and Lautrec himself.

The cover of a June 1893 issue of *Le Mirliton* (opposite, with detail), designed by Theophile-Alexandre Steinlen, is an amusing portrayal of the writer Maurice Barrès examining Lautrec's poster for Bruant.

Overleaf: Jeanne Wenz, the sister of a fellow pupil at Cormon's studio, modeled for both *A la Bastille* (1888, page 34) and *Woman with a Pink Bow* (1886, page 35).

Tolau-Segroeg, the "Hungarian from Montmartre"

An influential figure for Lautrec's work during this period was the French painter and engraver Jean-Louis Forain (1852–1931), who had once made a portrait of Lautrec's father, Count Alphonse. Forain cast a penetrating eye over society's underworld and used satire as a means of sublimating the grotesque and tragic in the comedy of human life. He encouraged Lautrec's humorous drawing.

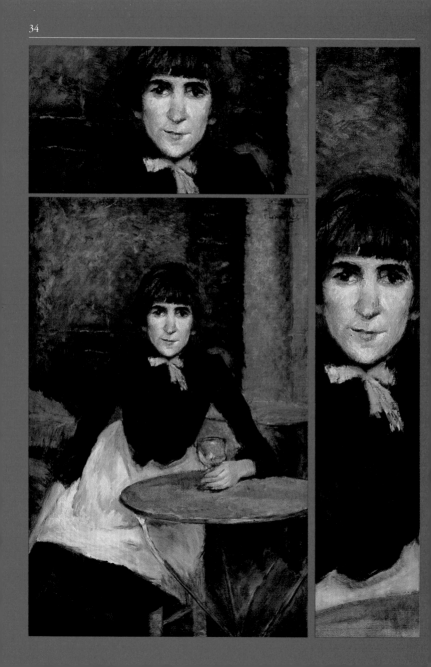

Lautrec's first important graphic works date from the late 1880s, when he began to illustrate magazines and journals. His first contribution was on 6 September 1886 to *Le Courrier Français,* for which Jules Roques (a publicity agent for a maker of throat lozenges) had assembled a group of talented illustrators and engravers such as Steinlen, Forain, and Léon-Adolphe Willette. At the magazine's annual ball in 1889 Lautrec wore the costume of an altar boy, carrying a wolf's head on a pole instead of a holy water sprinkler. He attended the first ball of the Quat'z-arts, organized at the Elysée-Montmartre by the photographer Simonnet, dressed as a lithographer in working-class blue overalls and a soft felt hat.

The artist happily threw himself into practical jokes and tricks, a sign of someone who does not take himself entirely seriously, and used to put on bizarre costumes to fool his friends. From an early age Lautrec had been drawn to dissimulation and disguise. Adopting the pseudonym Tolau-Segroeg, the "Hungarian from Montmartre, who has visited Cairo and is staying with a friend, is talented and will prove it," he exhibited at L'Exposition des Arts Incohérents in 1886, a forum for humorous and anarchistic artists and an obvious parody of the official painters' Salon, where it was a fashionable practice to exhibit under an assumed name.

Lautrec's entries were watercolors and a canvas entitled *The Batignolles Three and a Half Years BC,* an oil painting on emery cloth, exhibited as number 332. For the same exhibition in 1889 he produced *Portraits of a Miserable Family Stricken with Chicken Pox,* still under the pseudonym Tolau-Segroeg, living at "Rue Yblas under the third lamppost on the left, pupil of Pubis de Cheval, specializing in family portraits on a yellow pastel background." Lautrec was in more than one respect a forerunner of the Dada movement.

Lautrec loved to dress up, whether as a clown (left), a woman, a choirboy, a Japanese man, or an imam (below), preaching to an imaginary crowd. "Pray for him," wrote Countess Adèle to the painter's paternal grandmother, "studio life, excellent as it may be professionally, is a trying time for a young man."

An Eastern influence appears to reign in the studio scene opposite. Barely recognizable, dressed in various Oriental costumes, are Lautrec and two of his friends.

First Female Conquests

Lautrec's physical
deformities in no way
affected his sexual drive.
Indeed, he was more than
ordinarily virile and
indulged a keen appetite
for the female sex by
paying prostitutes whom
he met in bars and brothels.
As an artist, he captured all that
was beautiful in this world of

Lautrec was not afraid
to caricature himself.
The dazzling lines of this
satyr's silhouette (below)
anticipate Picasso.

venal love. His friend Maurice Joyant recounts: "He asked several women, half draped in their slips, to dance hand on hip to the music of a mechanical piano. He made them advance and retreat until they were directly in front of him; then he went into ecstasies over their attitudes, which reminded him of *Spring* by Sandro Botticelli and the frescoes of Benozzo Gozzoli." Women always figured prominently in his life and his work. They

"She's first-rate! Doesn't she look a slut! It would be wonderful if we could use her as a model!" Thus Lautrec urged Henri Rachou to approach Carmen Gaudin. This portrait of her dates from 1884.

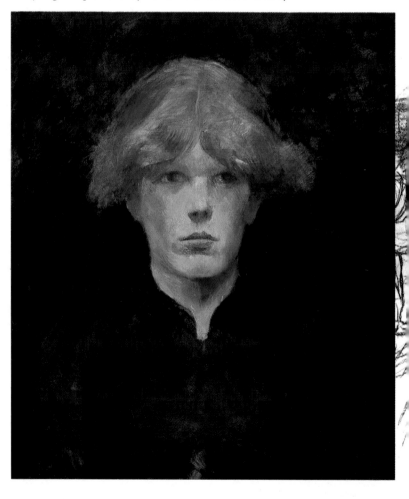

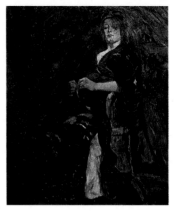

were his muses, his advisers, sometimes his mistresses, but above all his models. He portrayed their characters with great economy of means, a few technically brilliant lines sufficing to convey his keen psychological perception.

Through Bruant Lautrec met Carmen Gaudin, a woman who sang under the name Rosa la Rouge. In place of a "dangerous tart"—the image Carmen projected in her songs—he found a quiet, sickly, working-class girl who was extremely punctual. She quickly became one of his favorite models, the subject of *Carmen, At Montrouge, Rosa la Rouge,* and *Redhaired Girl in a White Jacket.* Another model was his friend Jeanne Wenz, whom he met at Cormon's studio. She posed as Nini Peau de Chien, the seductress of the Bastille district, heroine of Bruant's famous song.

The entrancing wife of René Grenier, who shared his studio, also sat for Lautrec. In *Madame Lily Grenier* (1888), she is dressed in a kimono.

Suzanne Valadon, Lautrec's Muse

Lautrec's first—and possibly only real—love was Marie-Clémentine Valade, who was known as Suzanne Valadon (1867–1938). This young woman, born to a poor

"Lily [Grenier], with her flaming hair, the fierce line of her jaw, her milky complexion with its minute red freckles, was most desirable, and formed the centre of a group of admirers who hoped for some private successes by dint of paying homage. Lautrec had no such hope; he knew that Lily had no desire for near-dwarfs, and he was content to be an amusing companion.**"**
François Gauzi,
My Friend Toulouse-Lautrec, 1957

S uzanne Valadon was probably the model for this charcoal study for *The Laundress* (1888, left).

O verleaf: Carmen Gaudin was the model for *The Laundress* (1888, page 40) and *Redhaired Girl in a White Jacket* (1889, page 41).

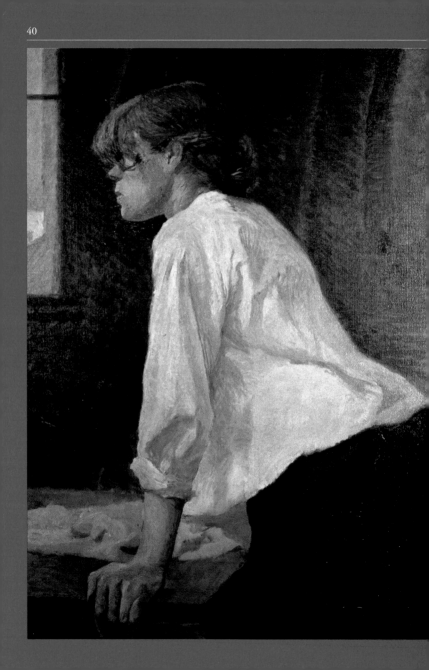

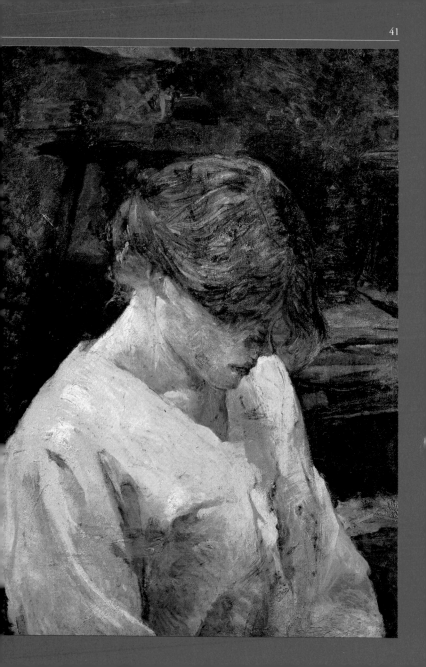

family in the Limousin region of central France, began to paint and draw in the mid 1880s, while working as a laundress in Paris. Later she joined the Cirque Molier as an equestrienne and trapeze artist. After being injured in an accident, she became an artist's model and sat for Degas and Puvis de Chavannes, inspiring all the female figures in the latter's *Sacred Grove*.

It was at this point, in 1889, that Lautrec met and fell madly in love with her. He was seen in her company at the Mirliton, the Chat Noir, and the Elysée-Montmartre.

For two years Valadon tried in vain to persuade Lautrec to marry her, eventually even feigning a suicide attempt. Discovering her trickery, Lautrec lost any lingering illusions about Parisian women and decided to break off the relationship, which nevertheless continued, intermittently, until 1891.

The young and sentimental artist from the provinces was becoming the pitiless observer-voyeur of the women of the Belle Epoque (as can be seen in *Hangover* and *Suzanne Valadon*). Occasionally, however, inspired by a particular model, Lautrec's paintings could still convey a feeling of great tenderness.

Suzanne Valadon, future mother of the painter Maurice Utrillo.

In 1888 the painter executed several portraits of an unknown young woman, the highly attractive Hélène Vary (sometimes nicknamed Juliette), a neighbor whom he had known in her childhood and whose features he admired. He had numerous photographs taken of her face, which he later incorporated into several of his paintings.

The Cirque Fernando

Like Degas, Lautrec loved the circus—its animals, clowns, acrobats, and riders. In *Cirque Fernando: the*

Lautrec asked François Gauzi to photograph Hélène Vary (above) so he could paint her portrait. "Her Greek profile is beyond compare," he enthused.

Equestrienne (also known as *The Ringmaster*), painted in 1888, he deliberately presents the ring from an angle that cuts off the figures at the edge of the scene; in the center the female rider gallops on the back of a dappled horse, lightly touched by the ringmaster's long whip.

The canvas was bought by Joseph Oller, the founder of the Moulin Rouge, who hung it in the hallway of his establishment. (Georges Seurat, whose studio was close by, is reported to have admired it at length.) This was the start of a long series of works devoted to the circus, a field in which Lautrec became the undisputed master.

A few years later, at a bar called Achille's on the Rue Scribe, Lautrec met two clowns from the Nouveau Cirque, Footit and Chocolat, who had come to dance after the show. Their pranks inspired a series of sparkling lithographs.

Princeteau brought Lautrec to the Cirque Fernando early in the 1880s. The young man quickly developed a passion for the circus, which had been made fashionable by the Impressionists and contemporary illustrators. On seeing Lautrec's first large and ambitious composition, the *Cirque Fernando* (1888), Belgian painter Théo van Rysselberghe observed, "The little dwarf is not at all bad.... Never exhibited. Doing very amusing things at the moment. *Cirque Fernando*, prostitutes and all." Suzanne Valadon was the model for the equestrienne in pale green.

At the Moulin de la Galette

Also in 1888 Lautrec presented eleven pictures at the Exposition des XX in Brussels. They were well received by the critics and did much to make his work better known outside his immediate circle. Theo van Gogh took a few of his pictures on consignment for the gallery he managed.

For Lautrec, this was the beginning of a period of intense artistic activity devoted to the subject of the Montmartre dance halls. *At the Moulin de la Galette,* painted in 1889 and exhibited the same year at the Salon des Indépendants, is one of Lautrec's first large-scale compositions portraying a dance scene from life. The sense of space in the painting is rendered by the receding diagonal of the bench on which the four figures lean. The picture is also a series of portraits that show the close attention to detail that from now on characterizes Lautrec's major works. In front of the crowd of dancers, the man in the bowler hat, the painter Joseph Albert, looks past the three women on the bench.

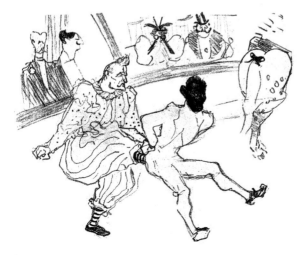

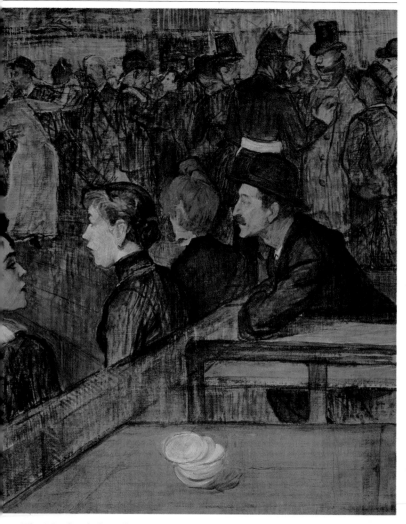

The Moulin de la Galette, on the top of the hill of Montmartre, was the last rustic dance hall in Paris. There workmen in their Sunday best joined men of the lower middle classes trying to pick up women. On the site of the old threshing ground was an earthen dance floor, where

At the Moulin de la Galette (1889) was first owned by painter Joseph Albert, the man in the bowler hat.

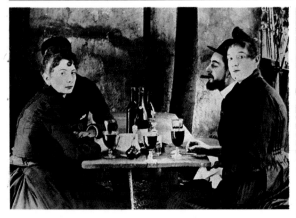

the clientele could mingle with professional performers, many of whom Lautrec frequently employed as models: Grille d'Egout ("Drain Cover"), La Môme Fromage ("Mistress Cheese"), and, above all, La Goulue ("The Glutton"), who made her debut there. La Goulue would become one of the most celebrated attractions of the best-known establishment of the period—the Moulin Rouge.

The Opening of the Moulin Rouge

The date of the opening of the Moulin Rouge, 5 October 1889, was a major event of the Belle Epoque in Paris. On the site of an unassuming popular dance hall, the Reine Blanche, impresario and entrepreneur Charles Zidler built a vast entertainment complex. The decorator Léon-Adolphe Willette crowned it with an elegant wooden mill, whose red arms seemed to agitate the air above the Boulevard de Clichy (see page 53).

On the vast dance floor one could see Nini Patte en l'Air ("Nini Foot in Air"), Grille d'Egout, La Môme Caca ("Mistress Turd"), Clair de Lune ("Moonlight"), Demi Siphon ("Drain Trap"), and La Mélinite ("Dynamite") under the wing of Valentin le Désossé ("Valentine the Double-jointed"), so named because of his suppleness. For their amusement customers were provided with a lounge bar, a garden, tame monkeys, and a huge papier-mâché elephant that accommodated an

Lautrec (above left) drinking al fresco at the Moulin de la Galette. Next to him is La Goulue, star of the Paris dance halls and one of his favorite models. In *At the Moulin de la Galette* her blonde and upright chignon is recognizable from behind as she bends sideways on the dance floor. In 1887 Lautrec did a quick sketch of her (above) beside the lanky figure of her partner, amateur dancer Valentin le Désossé.

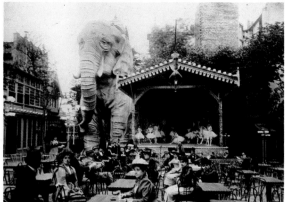

orchestra, a troupe of belly dancers and, from time to time, the international cabaret star Le Pétomane, who drew audiences from all over Europe.

This entertainment factory quickly became one of Lautrec's favorite haunts. It was frequented by members of the most important aristocratic and royal families of Europe—the Prince of Wales, the future Edward VII, was a regular visitor—and Parisians came in throngs, drawn by the Montmartre atmosphere. When Zidler offered to hang two of Lautrec's largest paintings over the bar, Lautrec agreed without hesitation.

Lautrec had already established his priorities in life: fun in preference to honors, Montmartre in preference to the "good taste" of Paris salons.

"When I See My Backside in Your Paintings, I Think It's Beautiful"—La Goulue

Of all the marvelous figures that Lautrec saw at the Moulin Rouge, it was La Goulue who inspired his most celebrated works.

Louise Weber (1870–1929), known

The garden of the Moulin Rouge (above) was dominated by the figure of a huge elephant, a vestige of the Universal Exposition. Below: Valentin does the splits, while La Goulue adopts the position known as "the guitar."

as La Goulue, was a native of Alsace, a region on
the French-German border. Starting as a laundress,
she was soon employed by the Cirque Fernando
as a performer, then appeared at the Moulin de la
Galette, where she met Renoir, moving on to the Jardin
de Paris in 1890.

Between 1890 and 1895 she was one of the great

The stars of the
quadrille (opposite,
from left to right); La
Môme Fromage, Grille
d'Egout, and La Goulue.
According to *Le Figaro
Illustré,* Lautrec was the
latter's "official painter."

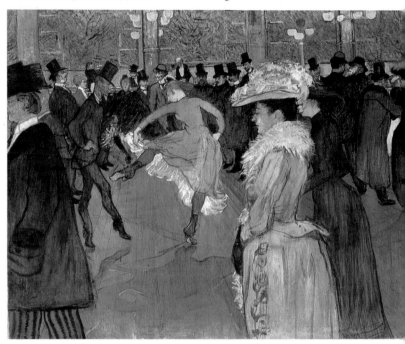

stars of the Moulin Rouge. She had invented her
own act, the famous "naturalist quadrille" derived from
the cancan, during performances of which the dancer
would place her leg behind her head and wind up
doing the splits with an earsplitting shriek.

Lautrec followed La Goulue's progress closely for
eight years, from her appearances at the Elysée-
Montmartre, near Bruant's cabaret, to the end of her
career. When her star began to fade, she resorted to
appearing in a fairground booth at Neuilly. In 1895

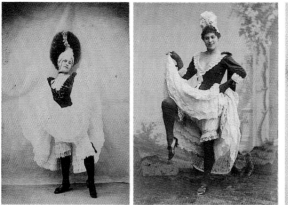

Lautrec decorated the booth with two panels that are well known today.

Captivated by this woman who once whispered in his ear "when I see my backside in your paintings, I think it's beautiful," Lautrec portrayed her in some ten canvases, posters, and lithographs. Several of them rank among the masterpieces of his oeuvre.

Exhibited at the Salon des Indépendants in 1890, *At the Moulin Rouge: the Dance* (opposite) depicts a public rehearsal. The colors are wonderfully vivid, and Lautrec cleverly exploits the contrast between the vitality of the dancers and the static air of the spectators. He also plays on the ambiguity of his figures. Is the elegant female wearing pink in the foreground an adventurous bourgeois or a prostitute? In the background are Maurice Guibert, Paul Sescau, and François Gauzi.

Overleaf: *La Goulue Entering the Moulin Rouge* (1891–2), with La Goulue between her sister and La Môme Fromage (page 50) and *Starting the Quadrille* (1892), featuring a recalcitrant dancer (page 51).

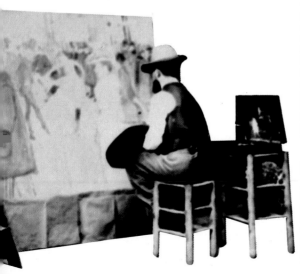

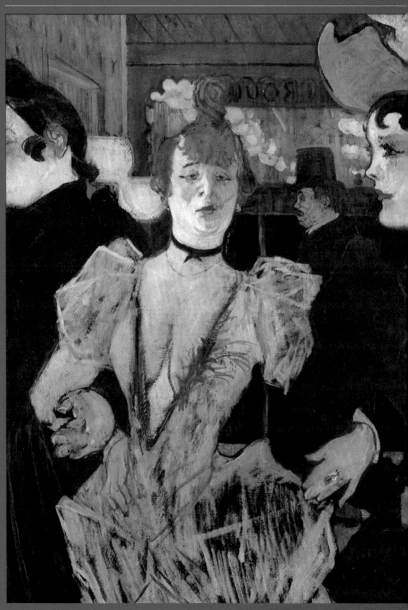

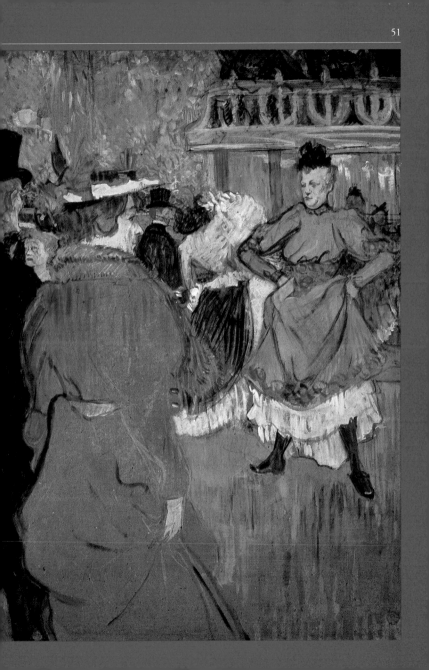

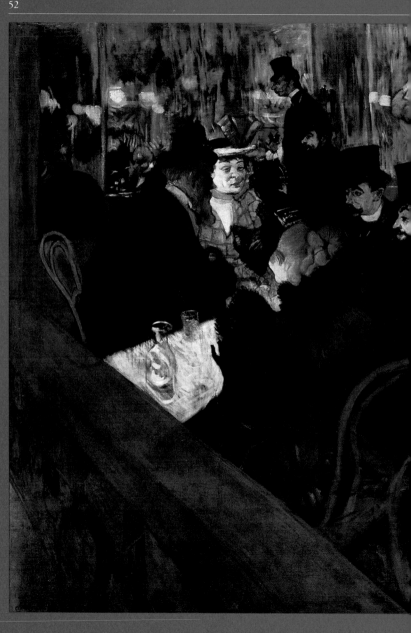

Next to his cousin Gabriel Tapié de Céléyran, Lautrec lurks in the background of *At the Moulin Rouge* (1892–3, left). La Goulue arranges her hair. The garish figure on the right resembles May Milton.

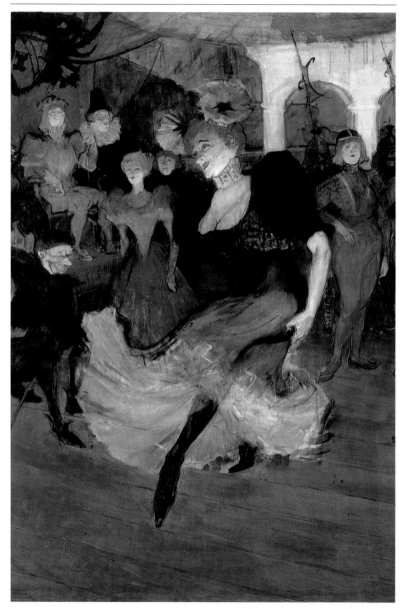

By 1890 Toulouse-Lautrec was at the peak of his artistic powers—and famous. This was the period when he created his finest paintings and best-known posters. He also took up lithography, becoming one of its most outstanding practitioners.

CHAPTER III
THE YEARS OF LIGHT

Dance-hall performer Marcelle Lender was a favorite of Lautrec's. In this 1896 painting (detail opposite) she is shown dancing the bolero in the popular operetta *Chilpéric*. At right is a clever photo montage of the painter working on a self-portrait.

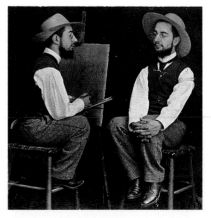

First Posters

The painter Jules Chéret (1836–1932), described by art critic Félix Fénéon as "the Tiepolo of double colombier" (an old paper format then generally used for posters), designed the poster advertising the October 1889 opening of the Moulin Rouge. It features dreamlike dancers riding donkeys in front of the distinctive outline of the new temple of dance.

Lautrec, a great admirer of Chéret, was asked by Charles Zidler to design the next poster. Going straight to the point, he drew La Goulue performing with the curious figure of Etienne Renaudin (1843–1907), known as Valentin le Désossé—a lawyer's son with a birdlike profile and a nutcracker chin who had a passion for dancing and always wore a top hat glistening with oil. Soon Lautrec's poster could be found all over Paris, causing a sensation with its arresting colors and incisive silhouettes. Clearly showing the influence of Japanese prints, the work put Lautrec forcefully in the public eye.

It was the first modern poster, a true work of art, and in no time it became highly prized by collectors, who would snatch them down from the walls on which they were displayed. In *L'Oeuvre* (1886) Emile Zola describes the young artists on the Rue de Seine insulting the Académie des Beaux-Arts, whereas a "poster printed in three colors" advertising a traveling circus drew cries of admiration. In the anarchist magazine *Le Père Peinard* Félix Fénéon

Lautrec and Trémolada, assistant to Joseph Oller and Charles Zidler, owners of the Moulin Rouge, inspect its first poster, designed by Chéret in 1889 (above). The advertisements of the time invited the public to "a very Parisian show which husbands can attend with their wives." —an ironic slogan, given that the Moulin Rouge quickly acquired a reputation as "the greatest market of free love" in Paris.

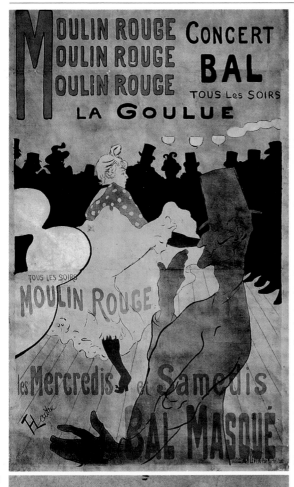

Instead of Chéret's windmill and jaunty woman miller (above), Lautrec featured in his poster (left) a star, La Goulue, and a dance act. Before a line of shadow puppets, representing the audience, and behind the lanky silhouette of Valentin le Désossé, La Goulue dances "the guitar," which *Paris Cythère*, in 1894, described as follows: "The woman raises her unbent leg until it is virtually at a right angle to her body; with one hand she holds her lower leg, as if it were the handle of a guitar, with the other she simulates the plucking of strings on her thigh."

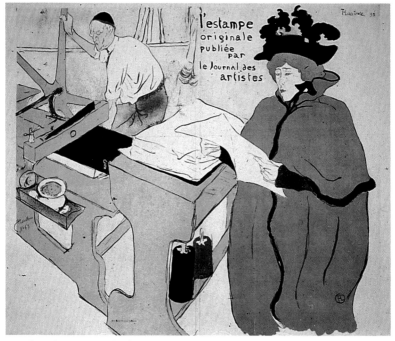

urged readers to tear the finest posters off the walls of Paris and thus "get hold of paintings with a bit more zip than the dismal daubs that look as if they're done in licorice juice that so delight the *cognoscenti* arseholes."

First Prints

At the beginning of the 1890s, as photography was forcing engraved reproductions of paintings out of fashion, knowledgeable art lovers became increasingly interested in original prints. With these clients in mind, savvy publisher André Marty launched a series of artists' prints, *L'Estampe Originale.* Lautrec designed the cover of the first issue. Moulin Rouge performer Jane Avril was his model.

Little by little Lautrec built up his reputation as a printmaker. People talked increasingly about the work of this aristocrat, whose boldness was matched by his technical mastery. The circle of interested collectors began to grow.

In 1893 art dealer and publisher André Marty launched *L'Estampe Originale,* a quarterly selection of the work of the best artists of the period. In the cover illustration for the first issue (above), Lautrec featured the dancer Jane Avril and paid tribute to her artistic interests. He showed her looking at an impression fresh from the press of *père* Cotelles, a printer at the Paris firm of Ancourt & Cie, where Lautrec had been introduced to the subtle techniques of lithography.

The figure of Jane Avril adorning the cover of the first issue of *L'Estampe Originale* evolved in stages. Lautrec first did a study in oil on a large piece of cardboard (left), capturing the dancer's attentive air with remarkable vigor of line. He then worked out the details of her face with watercolor.

Lautrec's charcoal sketch *The Hanged Man* (1892, above) conveys a strong sense of drama. In the definitive version of the poster (page 67), all that emerges from the darkness of the background is the condemned man's shirt, parts of his face, and the silhouette of the gallows, tragically illuminated by the hangman's candle. The more concentrated blackness of the man's legs intensifies the sense of suspension.

In 1892 the daily newspaper *La Dépêche de Toulouse* commissioned Lautrec to design an advertisement for a novel set in the 18th century, *Les Drames de Toulouse,* by journalist A. Siégel. The result was *The Hanged Man,* in which Lautrec lit the figures from below—like the stage in a *café-concert*—so that they stand out dramatically against the dark background. This is one of the rare posters in which Lautrec displays a sense of anguish.

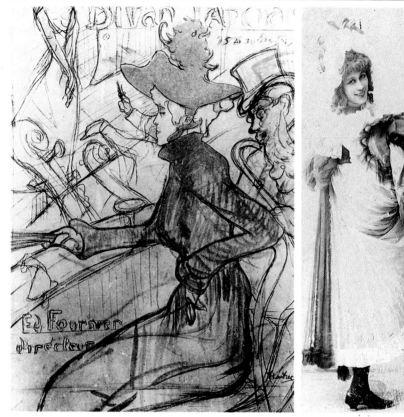

The following year, in an advertisement for the memoirs of a prison priest that appeared in *Le Matin* (page 66), Lautrec showed the tragic figure of a man condemned to the guillotine, in front of a line of mounted guards whose disturbing dark silhouettes are pronounced against the light background.

In the Steps of the Japanese Masters

In his other engravings Lautrec is revealed above all as a witty and playful observer of his age. Whether one considers the delightful *Divan Japonais* (1892–3), named after the *café-concert* featuring the young singer Yvette

This photograph of Jane Avril dancing was the basis of one of Lautrec's portraits of Jane Avril and of his poster *Jane Avril* (page 64). Jane also appears in *Divan Japonais* (study, above left; poster, page 65), sitting next to the critic Edouard Dujardin. They are listening to a singer with the famous long black gloves.

Guilbert, or *Jardin de Paris* (1893), depicting another artiste, the singer and dancer Jane Avril (1868–1943), Lautrec seems to have been fascinated by the play of shapes and monochrome areas that he discovered by leafing through books of prints by such great Japanese masters as Kitagawa Utamaro (1753–1806), Shunsho Katsukawa (1726–92), and Hokusai Katsushika (1760–1849).

In the same style, he portrayed his friend Aristide Bruant in the poster for the latter's show in 1892. The performer is shown draped in a bright red scarf, a wide-brimmed hat on his head.

Bruant had great difficulty persuading the manager of the Théâtre des Ambassadeurs, Pierre Ducarre, to accept Lautrec's poster. Dissatisfied with the preliminary sketches that Bruant showed him, Ducarre secretly invited an unknown poster artist by the name of Lévy to submit an alternative. But, threatening to cancel his engagement, Bruant insisted that Lautrec's poster be displayed. It would later be acclaimed as one of the masterpieces of its genre.

The portrait of Bruant helped win recognition for the poster as a genuine art form, worthy of having museums of its own.

Dancers, Singers, and Female Clowns

To inject new life into the Moulin Rouge, which had been rather put in the shade by the well-publicized opening of the

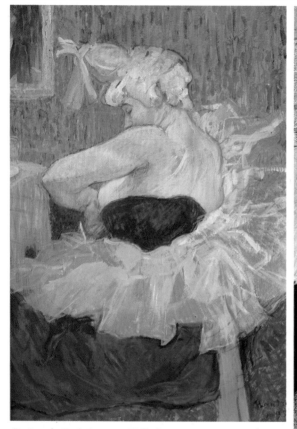

Casino de Paris in 1891, Zidler's new partner, Joseph Oller, hired a cluster of stars: Cha-U-Kao (from "Chahut-Chaos," meaning hurly-burly), the woman Lautrec painted with a yellow corolla; female clowns of the Nouveau Cirque; La Macarona ("the Macaroon"); Jane Avril ("La Mélinite"), who became a proper actress; Pomme d'Amour ("Love Apple"); Rayon d'Or ("Ray of Gold"); Grille d'Egout; and, of course, La Goulue.

Captivated by these women, Lautrec divided most of his time between his studio in the Rue Caulaincourt and the *café-concerts,* where he watched young and unknown talents blossom into stars of the Paris stage.

But for the works of Lautrec, the female clown Cha-U-Kao (1895, oil on cardboard, left, and color lithograph, right) may have been forgotten.

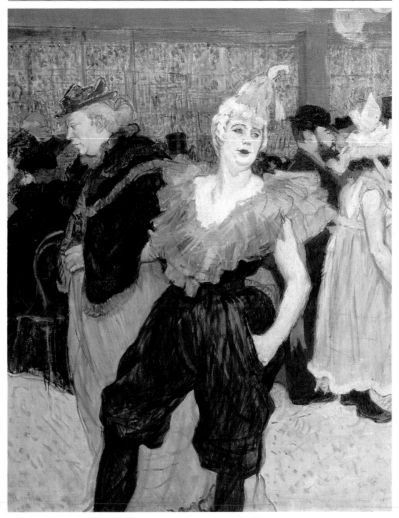

Two women in particular inspired him: Jane Avril, an outwardly demure performer at the Moulin Rouge, and Yvette Guilbert, whose elongated silhouette and black elbow-length gloves fascinated her male admirers. Lautrec was responsible for bringing lasting fame to both.

This 1895 painting of Cha-U-Kao includes the bearded profile of playwright and novelist Tristan Bernard (1866–1947).

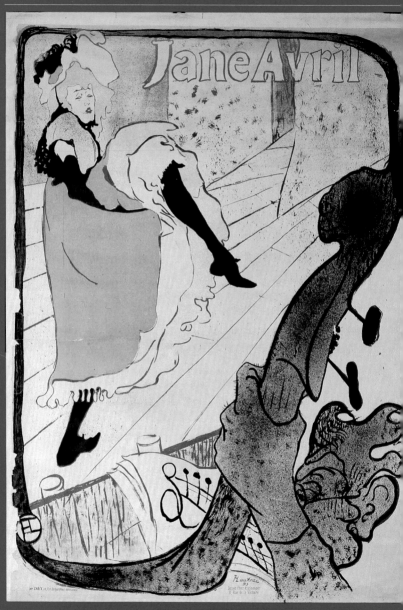

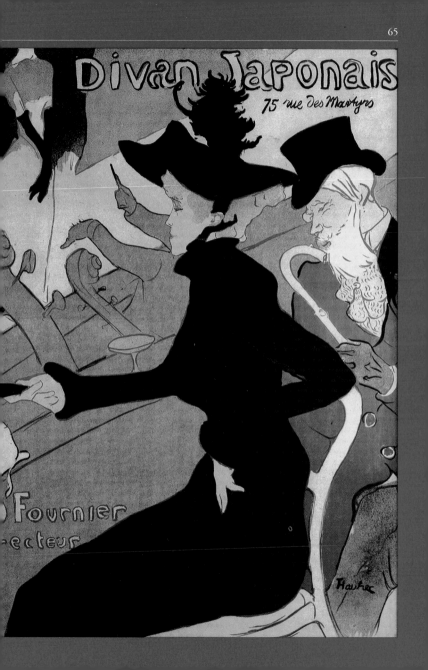

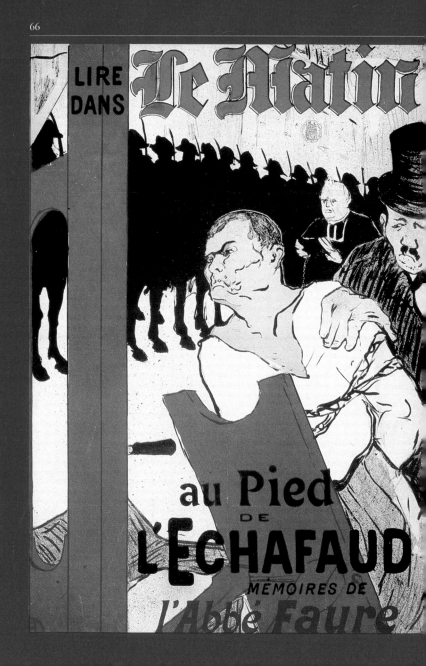

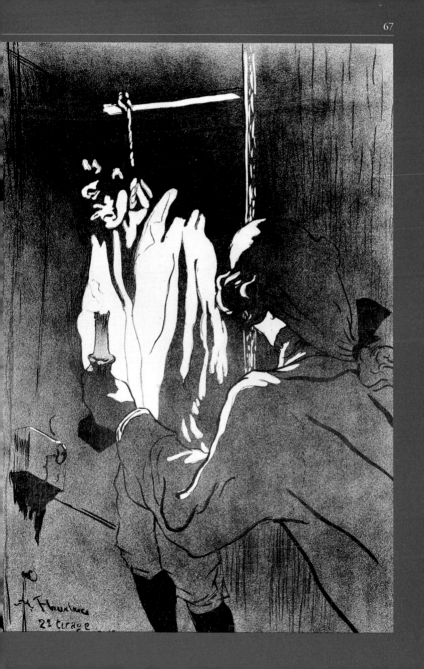

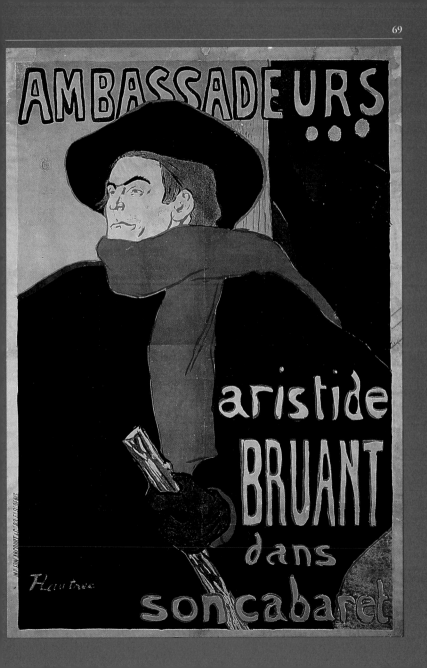

Jane Avril, "La Mélinite"

Lautrec became intimate
with Jane Avril in 1890.
Their genuine
friendship was
in no way
threatened by
La Mélinite's
many
"protectors."
The
illegitimate
daughter of a
well-born
Italian émigré, the
Marchese Luigi de Font, and
a demimondaine known as
La Belle Elise, Avril was in appearance
ethereal, almost sickly. In fact she was
blessed with tremendous energy—hence
her nickname: Melinite is an explosive
resembling dynamite. She was barely
adolescent when a medical student into
whose arms she happened to have fallen
persuaded her to dance in public on the
floor of the Bullier. At the age of twenty
she made her debut at the Moulin
Rouge, later moving on to the Divan
Japonais and the Jardin de Paris, where
she was resoundingly successful.

Avril was hailed by the critics as the
"incarnation of dance," and she quickly
became one of Lautrec's most
characteristic figures. He portrayed her
not only dancing but also arriving at the
Moulin Rouge dressed in an exquisite
coat with a fur collar. It is hard to see in
this elegant and respectable lady the
dancer famous for the way she raised her
leg, "like an orchid in ecstasy," according
to the newspapers, during the frenzy of

the quadrille, a popular dance. She modeled for Lautrec in his studio, and the "brilliant invalid," as he was known, took her to lunch in the fashionable restaurants where she used to meet her friends.

More cultivated than one might have suspected, Avril was acquainted with the French poets Paul Fort, Léon Dierx, Stéphane Mallarmé, and Paul Verlaine and the novelist Joris-Karl Huysmans. In 1896 she played the part of Anitra in Lugné-Poë's production of Henrik Ibsen's *Peer Gynt*. After Lautrec's death Avril concentrated entirely on the theater until she married journalist and draftsman Maurice Biais and settled into a respectable bourgeois life. She died penniless in a home for the elderly.

In this sketch of Jane Avril (opposite right), Lautrec diluted his oil paint with turpentine to achieve a matte effect, and touched it up with heavy chalk lines— a favorite technique for this type of work on cardboard. The drawing by Grass Mick (left and opposite left) shows the music critic Edouard Dujardin watching Jane Avril's frenzied dance while Lautrec sketches his friend with "the inspired leg" in action.

Lautrec (below) wearing Jane Avril's feathered hat, cloak, and feather boa.

Yvette Guilbert, "the *Fin-de-siècle* Raconteur"

Another figure who haunts Lautrec's work, doubtless because she both intimidated and fascinated him, was Yvette Guilbert (1868–1944), the woman in black gloves. First a fashion model, then a salesperson at the store Printemps, she started her theatrical career at the Bouffes du Nord, appearing in Alexandre Dumas' *La Reine Margot*. In 1886, she moved to the cabaret the Eldorado and eventually became a solo entertainer, reciting monologues written for her by writer and critic Maurice-

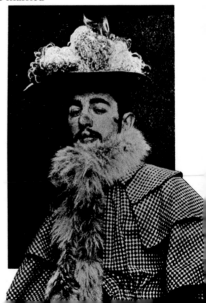

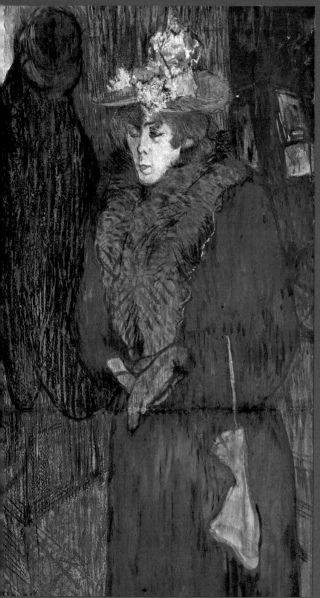

It was at a fancy dress ball held in the Salpêtrière asylum, where she had been admitted for the treatment of a nervous disorder, that Jane Avril discovered the "enlightenment of dance." She recounts in her memoirs that dancing cured her. Who, seeing the elegant and respectable exterior, the bonnet trimmed with flowers, the magnificent fur collar of *Jane Avril Entering the Moulin Rouge* (1893, left), would have suspected the wild dancer concealed beneath? Or that this woman, with her air of severity and her little yellow bag hanging like a plumb line, was about to transform herself into *Jane Avril Dancing* (1893, opposite), lifting her legs and her enticing black underskirt high in the air?

"Jane Avril regularly changed her protectors, but hated breaking off relationships. So she left without a word of explanation to her admirer of the moment, abandoning even her Lautrecs. As she loved his pictures, her painter painted others for her."
Philippe Huisman and Geneviève Dortu, *Lautrec by Lautrec*, 1964

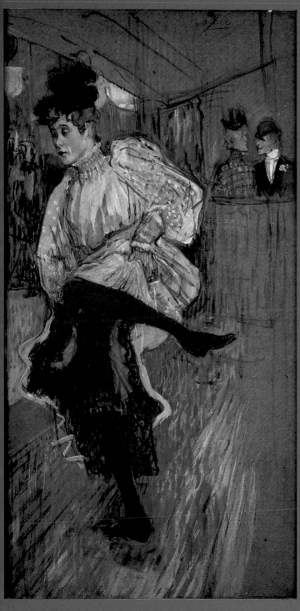

"Something was astir in the thick of the crowd," recounts Paul Leclercq, cofounder of *La Revue Blanche* and friend of Lautrec's, "a hedge of people was forming: Jane Avril danced, turned, gracefully and lightly, a little mad, pale, thin, distinguished…she turned, around and back, weightless, besieged with flowers; Lautrec voiced his admiration."

Behind the dancer in this painting of Jane Avril there is a caricature of a couple. The man in a bowler hat is the English painter William Tom Warrener, who frequently visited the Moulin Rouge. Lautrec used him as the model for his 1892 lithograph *The Englishman at the Moulin Rouge* (page 105).

Charles Donnay. Jean Lorrain, an influential journalist of the Belle Epoque, wrote in vindication of her performance at the cabaret the Divan Japonais. In 1890 she appeared at the Moulin Rouge, her long slender figure sheathed in a green satin dress with a plunging V-shaped neckline, her arms encased in black gloves resembling long inky nets.

Other painters, too, immortalized "the *fin-de-siècle* raconteur": Charles-Lucien Léandre, Sem, Bac (Ferdinand-Sigismond Bach), Leonetto Cappiello, to cite only the best known. But none matched Lautrec in realizing to the full the figure and gestures of this woman who left no critic unmoved.

The newspaper *La Vie Parisienne* acclaimed the singer's triumphant performance at another cabaret, the Scala: "The magnificent prodigy of *fin-de-siècle* song was right to devote her very individual talent to a new genre." French novelist Edmond de Goncourt meanwhile recorded in his *Journal* a different, and much less flattering, comment by Lorrain, namely that her songs were so dismally smutty they amounted to "obscene vespers" and "a lament on potassium iodide."

When Lautrec made her acquaintance, Guilbert had just given up her recitation at the Eden of a text by French writer Catulle Mendès in order to do a takeoff, at the Moulin Rouge, of an English nurse and maid-of-all-work. Though Lorrain described her as having "a flat-chested figure, a bulbous nose, somewhat insipid eyes, eyebrows tilted at a slightly devilish angle, a coil of towlike hair around her head," Guilbert had a charm all her own, expressed as much in her talented storytelling as by her memorable figure. After highly successful tours in the United States and Europe, Yvette Guilbert

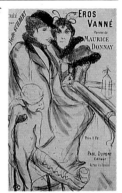

A cupid with a bandaged head and one leg in a plaster cast sets the tone for the title page of *Eros Vanné* (above), daringly unorthodox for the time in its many references to lesbian love.

"Yvette Guilbert [left], to whom we owe some of the most curious artistic performances of the *café-concert,* has just added to her already varied repertoire *Eros Vanné,* a delightful fantasy by the fine poet Maurice Donnay.... The incomparable star has, with her customary skill, declaimed the fine couplets of *Eros Vanné,* which have been very warmly received by the regulars of the Scala."
La Vie Parisienne,
1894

returned to enthusiastic audiences at the Théâtre des Ambassadeurs and the Folies Bergère. She nonetheless ended her days in relative poverty.

Overcoming his initial shyness in her presence, Lautrec produced an entire album of engravings devoted to the young actress in 1894, with a text by writer and art critic Gustave Geffroy. His work was heavily stylized and archetypal in character, drawing fresh fire from Lorrain, who wrote in horrified terms to Guilbert of "drawings copied from those on the walls of the Château-Rouge, this offensive edition in dirty green with its elongated shadows...." The same year Lautrec also illustrated a number of poems written for Guilbert by Maurice-Charles Donnay, including *Le Jeune Homme Triste* (The Sad Young Man) and *Eros Vanné* (Eros Exhausted).

Lautrec used this sketch of Yvette Guilbert (below) in the album he devoted to the actress, the title page of which is reproduced above.

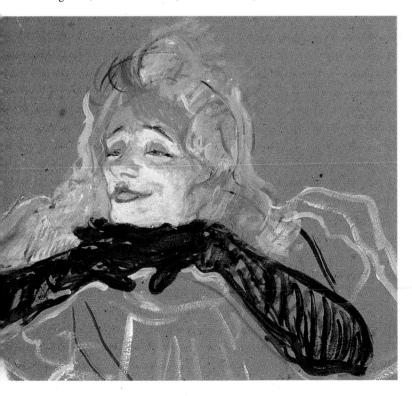

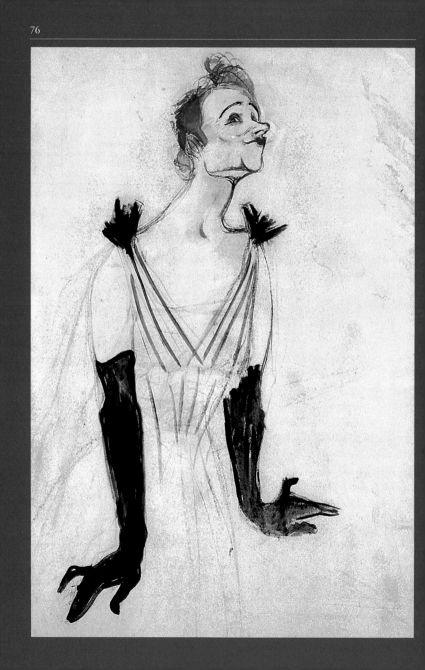

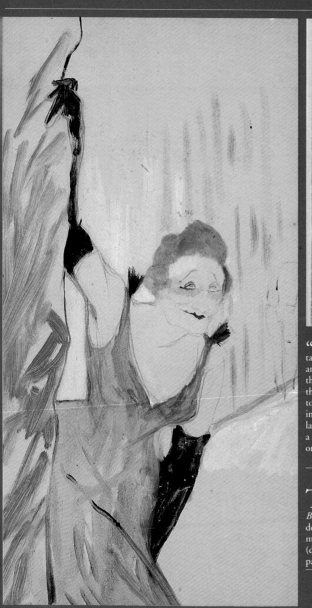

"Each performance
taught me many things,
and it was by seeing
the dramatic arts at work
that I myself learned
to sing! The actors
influenced my style, and
later, when I had to learn
a song, I concentrated
on 'acting' it."
Yvette Guilbert

This sketch, *Yvette
Guilbert Taking a
Bow* (1894, left),
developed into a fine
monochrome lithograph
(detail above), the last
page of her album.

An Acute and Ardent Spectator

Lautrec adored the theater and played a large role in recording for posterity the theatrical world of late-19th-century Paris. He attended a wide variety of establishments, from the highly prestigious Comédie Française to the much more popular theaters of the Boulevard du Crime, encompassing the Gymnase, the Vaudeville, the Renaissance, and the Athénée. He tracked down the actors—and, even more, the actresses—on stage or in the wings, and would often end the evening in their company, over supper at Petit Lucas, Paillard's, the Café Anglais, or Veil's.

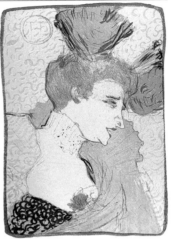

The world of the theater held a special place for him. It was on a ground of red carpet, like that found in the corridors of the Français, that he painted the fine portrait of his first cousin and confidant Gabriel Tapié de Céleyran, who had come to Paris to study medicine. Lautrec attended at least twenty performances of Hervé's operetta *Chilpéric* at the Théâtre des Variétés, where Marcelle Lender danced the bolero

Marcelle Lender, whose real name was Anne-Marie-Marcelle Bastien (1862–1926), made her debut at the Théâtre du Gymnase. Having traveled to the United States with the actor Coquelin, she returned to Paris and performed triumphantly in *Chilpéric* (detail page 54). In 1895 Lautrec produced this superb lithograph of her (above) printed in various stages, some of which were touched up with watercolor.

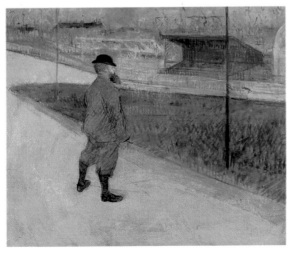

In addition to his work as a playwright, Tristan Bernard was also the sporting director at two Parisian racetracks —the Vélodrome de la Seine and the Vélodrome Buffalo, where Lautrec painted this portrait of him (1895, left).

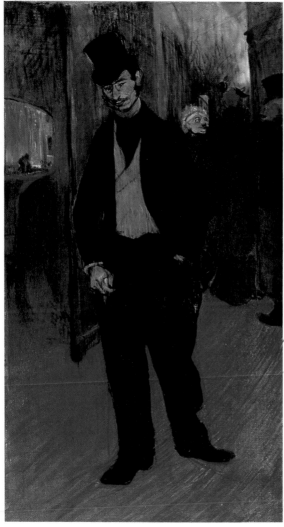

Lautrec's cousin Gabriel Tapié de Céleyran, who had come to Paris from Lille to continue his medical studies at the Hôpital Saint-Louis, introduced Lautrec to medical circles. The painter drew him in a top hat (below) and also painted his portrait (1894, left) in a corridor of the Comédie Française.

with castanets before a spellbound audience.
 Under the influence of his childhood friend Maurice Joyant, who had become an art dealer, replacing Theo van Gogh as manager of the Goupil gallery in Paris,

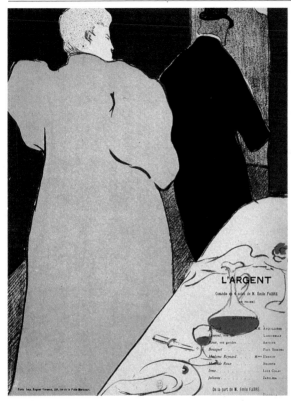

L'ARGENT

Comédie en 4 actes de M. Emile FABRE

Lautrec's art gradually moved away from the world of Montmartre and the *café-concerts*. He illustrated the literary works of Jules Renard, Jean de Tinan, Tristan Bernard, Julien Sermet, and Georges Clemenceau, thus broadening his sources of inspiration, which, over the years, became more intellectual.

After 1895 Lautrec was more often to be found in a theater than at a *café-concert*—though he went there, if truth be told, more to look than to listen. So engrossed was he by the play of light on the stage and the gestures of a particular actor or actress, that he could sit calmly through performances of often obscure symbolist plays, which at times provoked anger in the vociferous audiences.

Lautrec's boldly colored lithograph for the program (left) of Emile Fabre's play *L'Argent* —performed at the Théâtre Libre in 1895— shows the Reynard couple (characters in the play) walking away from their meal. The scenes in the lithographs above are from Maurice Beaubourg's play *Image*. In caricatural manner, Lautrec shows Aurélien Lugné-Poë, founder and director of the Théâtre de l'Oeuvre, horror-struck at the sight of actress Berthe Bady (his wife), who then faints.

The Théâtre Libre and the Théâtre de l'Oeuvre

The end of the century saw the development of the avant-garde theater, led in part by directors André Antoine, at the Théâtre Libre, and Aurélien Lugné-Poë, at the Théâtre de l'Oeuvre. Contemporary artists were commissioned to design programs, posters, and stage sets. The object was to achieve a "total spectacle," encompassing all forms of artistic expression.

This avant-garde theatrical movement strongly influenced the development of painters and sculptors, thanks largely to the number and quality of the artists invited to take part, among them the Norwegian Edvard Munch and the Frenchmen Pierre Bonnard, Edouard Vuillard, and Maurice Denis. Lautrec started to design posters for the Théâtre Libre in 1893. Rehearsals were attended by fans of the symbolist plays, undeterred by their sometimes obscure subjects.

A sort of court gathered around Catulle Mendès, the "prince of critics," whose portrait Lautrec drew from memory, portraying his bulging eyes and heavy profile.

Sarah Bernhardt (1893, above), playing the title role in *Phaedra* at the Théâtre de la Renaissance.

Lautrec worked for other theaters too, including some with more classical repertoires. And he painted and drew the "stars" of the time, who were as much in the limelight then as film stars are today. He drew Sarah Bernhardt, for instance, as Phaedra in Racine's tragedy at the Théâtre de la Renaissance (which she established in 1893) and as Cleopatra. He also made portraits of the celebrated Réjane (Gabrielle Réju) in *Madame Sans-Gêne* by Victorien Sardou and Edouard Moreau at the Théâtre des Variétés in 1894 and actor Jean Mounet-Sully in Sophocles' *Antigone* at the Comédie Française in 1893, beautifully conveying their personalities in a few lines.

The Box with the Gilded Mask (1894). "All plays are the same to me," Lautrec used to say. "The theater is good even when it's bad—I am still amused by it."

The Boxes

Lautrec was as interested in the audiences as he was in the stage. He concentrated particularly on the boxes, in his eyes a stage in miniature, where he could observe the social spectacle, the unfolding drama of life in *fin-de-siècle* Paris, where every excess was apparently allowed (*The Box with the Gilded Mask, A Box at the Theater, The Box During a Performance of Faust*). But it was in his portraits of actors, who by the nature of their trade exaggerated the traits of human behavior, that he could most freely express himself as a caricaturist.

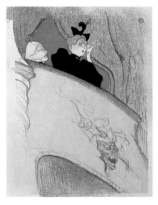

Taking the idea of a "total spectacle" even further, Lautrec designed the decor for *Chariot de Terre Cuite* (Earthenware Chariot), an obscure play drawn from Hindu mythology and translated by Victor Barrucand. On the left of the stage he placed an elephant, an identical copy of the one at the Moulin Rouge; on the right, a large cactus. Lugné-Poë commented on the "splendor" of the stage set in his memoirs.

For another play (Alfred Jarry's *Ubu Roi,* staged in 1896 by Lugné-Poë), Lautrec formed part of a team (also including Vuillard and Bonnard) commissioned to design the decor. Sadly, no trace has survived of the set of the first truly "scandalous play" of French repertory.

La Revue Blanche

Founded in Belgium in 1889 by Paul Leclercq, *La Revue Blanche* was taken over in 1891 by the Natanson brothers, Thadée and Alfred, and moved to Paris. It quickly became the leading publication of the most talented avant-garde writers and painters of the time, the focal point for a gifted group of artists.

Lautrec was one of its principal members and contributors. *La Revue* was much more ambitious, not to say elitist, than, for instance, *Le Rire,* which was launched the same year by Arsène Alexandre and also

In *A Box at the Theater* (1896–7, study top and lithograph above), the Rothschild's coachman Tom is shown behind a demimondaine, who chats with the owner of the Parisian lesbian haunt Le Hanneton.

regularly published Lautrec's engravings. Among the distinguished writers appearing in *La Revue Blanche* were Jules Renard, Marcel Proust, and Stéphane Mallarmé. Illustrations were provided by Pierre Bonnard, Félix Vallotton, Paul Sérusier, Maurice Denis, Edouard Vuillard, and Ker-Xavier Roussel, and intelligent articles appeared on the work of Paul Cézanne, Paul Gauguin, and Edouard Manet.

In February 1895, at the inauguration of "Alexandre's Bar" in Alexandre Natanson's luxurious apartment on the Avenue Foch, decorated by Vuillard, Lautrec officiated as master of ceremonies dressed as a barman all in white, with a waistcoat made from an American flag. Impassive, his head shaved for the occasion, he made his guests drink exotic cocktails that sent most of them into alcoholic stupors. His journalist friend Paul Leclercq (1872–1955) described the memorable evening: "Lautrec's imagination is inexhaustible. A series of drinks that had to be swallowed in one gulp was followed by a series of delicate pink cocktails supposed to be sipped slowly through a straw.... He also prepared solid cocktails, sardines in gin and port. He set them alight on a long silver dish and they unfailingly burnt unwary throats.... There were also prairie oysters spiced with Cayenne pepper."

The evening's victims included art critic Fénéon (whose portrait Lautrec later painted on one of the panels of La Goulue's fairground booth), writer Alfred Jarry, musician Claude Terrasse, theatrical promoter Alfred Athis (Alfred Natanson's pseudonym), writer and humorist Alphonse Allais, Tristan Bernard, writers André Gide and Pierre Louÿs (the pseudonym of Pierre Louis), politician Léon Blum, and actor Lucien Guitry. In short, anyone who was anyone in the literary and artistic worlds had gathered that evening at Lautrec's behest, and he took a wicked

P ierre Bonnard designed his first poster (above) in 1894 for *La Revue Blanche.*

L autrec's involvement in *La Revue Blanche* led to his great friendship with Misia and Thadée Natanson. The three of them shared a love of the country and seaside (below, a photograph from 1898).

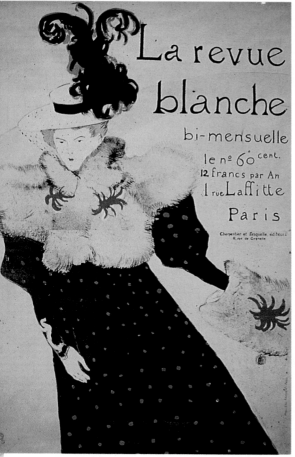

The elegant figure of Misia Natanson was the emblem of *La Revue Blanche* in the poster Lautrec designed in 1895 (left).

Félix Fénéon—portrayed on a panel in La Goulue's fairground booth (detail above)—was recruited by Thadée Natanson as a subeditor of *La Revue Blanche.* He had lost his job as a civil servant after being tried as an anarchist in 1894.

delight in forcing them to partake of his own tastes in drinking and festivity.

The Alluring Misia Natanson

Lautrec developed a great friendship with the Natanson family, Thadée and his attractive wife Misia in particular. He spent weekends at their country house at Valvins, near Fontainebleau, a popular gathering place for *La Revue Blanche* group. There the couple happily

entertained Bonnard, whom Lautrec found to be "detached and serene," Vuillard, "with his uneasy charm and melancholy smile," and Romain Coolus, a member of *La Revue Blanche* staff who was enthusiastic about the theater. Lautrec also joined the Natansons on outings to the Normandy beaches. Misia, an excellent pianist, introduced her friends to composers Gabriel Fauré and Claude Debussy. She brought together the worlds of music, literature, and painting. Mallarmé lived not far from Valvins, by the Seine, and came to relax in the company of the beautiful Misia, as did critic Octave Mirbeau, artist Odilon Redon, A. Vallette, founder of the *Mercure de France,* and Alfred Jarry. Through her Lautrec also met writers Pierre Louÿs, Maurice Maeterlinck, Paul Valéry, and Félix Fénéon.

Misia and Lautrec delighted in each other's company and there was great warmth and affection between them. She used to visit him in his studio, and he delighted in showing artistic and literary Paris that he, too, could attract beautiful women.

Maurice Joyant, a Faithful Friend

Lautrec's most lasting and productive friendship was with Maurice Joyant (1864–1930). The two men had met as students at the Lycée Condorcet in 1873 and ran into each other again ten years later. Joyant had given up his job at the French Finance Ministry and gone to work for Goupil, who, in addition to being one of the major art dealers of the time, owned several newspapers. Lautrec's first illustrations for the press appeared in Goupil's *Paris Illustré* (*First Communion*

"There is a game that he [Lautrec] plays with consummate skill that gives me the utmost pleasure. The rules are as follows. I sit on the ground in the garden, my back against a tree, deep in the delights of a good book. Lautrec then sits down near me, armed with a paintbrush, which he uses expertly to tickle my toes.... He pretends that I am in paradise and he draws imaginary landscapes on the soles of my feet..."

Misia Natanson

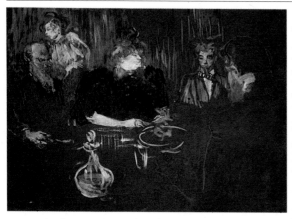

At Table with M. and Mme. Natanson (1895, left) shows one of the intimate gatherings at which the couple so excelled. Vuillard is on the left, the massive and dominant figure of Misia in the middle, while the painter Félix Vallotton is on the right, with the imposingly built Thadée Natanson seen from the back.

In July 1888 Lautrec published four colored drawings in *Le Paris Illustré,* among them, *The Tracehorse of the Omnibus Company* (below), illustrating an article by Emile Michelet entitled "Summer in Paris." Highly satisfied with his work, Lautrec wrote to his mother on 13 July: "Tante Emilie must have told you that my drawings have been published. I will send them to you on Monday."

Day and *The Tracehorse of the Omnibus Company).* Joyant gave Lautrec much useful advice on this type of illustration and on the layout of his designs.

Through Joyant Lautrec was in touch with the Van Gogh brothers, who both worked for Goupil's gallery. When Joyant replaced Theo van Gogh at the firm's gallery in the Boulevard Montmartre, instead of *art pompier* (the French academic art of the period) and paintings by the Barbizon school, Joyant exhibited works by the greatest Impressionists. Taking up the cause of avant-garde art, he organized exhibitions of work by Camille Pissarro, Eugène Carrière, Berthe Morisot, and, before he went to Tahiti, Paul Gauguin.

Lautrec long resisted suggestions that he exhibit his own work at Goupil's. He did, however, on Joyant's advice, submit a number of paintings to the Cercle Volney and the Salon des Indépendants, which his friend Paul Signac had helped to establish.

He also exhibited regularly at the Salon des XX in Brussels, a city he enjoyed visiting. (He once challenged the Belgian painter De Groux to a duel for publicly belittling the work of Vincent van Gogh.)

In 1893 Lautrec finally yielded to his friends' insistence and exhibited some thirty pictures in the Goupil gallery. It was there that Degas, a taciturn misanthrope, sparing with his praise, uttered his famous compliment to Lautrec: "Now, Lautrec, it's clear you are one of us!"

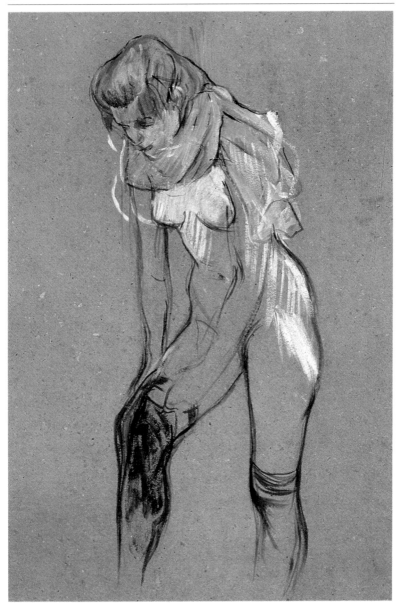

Women featured prominently in Lautrec's art. Whether one considers his portraits of the sublime Misia Natanson, the mysterious "passenger in cabin 54," or the jaded residents of the brothels, his finest works were devoted to the female sex. His models were taken from the highest to the lowest rungs of the social ladder.

CHAPTER IV
CITY OF WOMEN

Gabrielle, Marcelle, Rolande—Lautrec's favorite models were prostitutes, actresses, dancers. He conveyed their nobility, their sensuality, their talent— leaving the women of the bourgeoisie and the housewives to their respectable anonymity and preserving the austere and utterly different image of his mother that was deeply buried within him. Opposite and right: Two works from the 1890s.

The Painter of Ephemeral Stars

A hundred years later Lautrec would have been categorized as a "showbiz" painter. Most of the stars of his time sat in front of his easel and figured in his sketchbooks. Some became his mistresses, the majority he simply admired in silent frustration. He painted and drew them with the skill of a hunter tracking his quarry. In many cases their names have been handed down to posterity only because they were Lautrec's models: His brush made them famous.

He immortalized American-born dancer Loïe Fuller (1862–1928) as a flame-shaped silhouette, an effect she created with her dress of layered muslin voile, dramatically lit by a clever system that she herself developed and patented. Fuller danced at the Folies Bergère in 1892. Her act was distinguished by its highly original choreography, which quickly came to incarnate "symbolist" as opposed to "naturalist" dance. This woman, who became Rodin's agent in the United States, did not appreciate Lautrec's work and resolutely refused to ask Lautrec to design her posters. Yet, better than anyone else, Lautrec captured

"My dress was so long that I was always treading on it. I held it up with both hands and, lifting my arms in the air, flew around the stage like a winged spirit. A cry suddenly burst from the audience: 'A butterfly!' And I started whirling and running from one side of the stage to the other; then a second cry rang out: 'An orchid!'"

Loïe Fuller

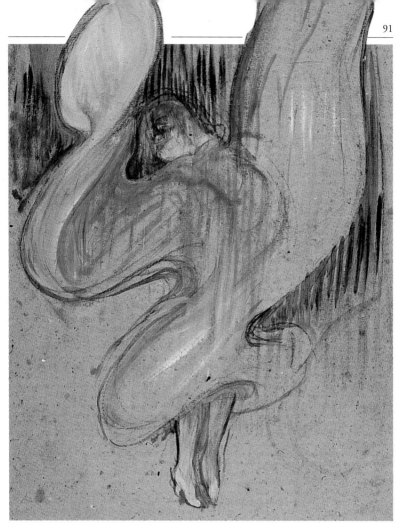

the essence of her performance, the impression she created of an evanescent torch.

May Belfort and May Milton

In 1895 Lautrec developed an infatuation for a young Irish singer named May Belfort, a close friend and protégée of Jane Avril. She performed at the Décadents, a *café-concert* on the Rue Fontaine, where she would

Fuller's veils, lit by multicolored projectors, inspired one of Lautrec's finest series of lithographs, touched up with watercolor and gold dust (1893 studies above and opposite above). The dancer did not like them.

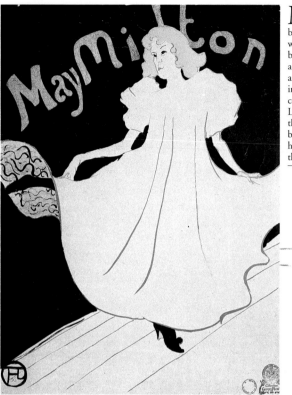

May Milton was not much loved by Lautrec's friends, who compared her to a bulldog. However, they acknowledged her talent as a dancer. She lives on in this one program (left), commissioned from Lautrec in 1895 for the comedy *L'Argent* by Emile Fabre, which had its premiere at the Théâtre Libre.

appear in pastel dresses with puffed and gathered sleeves, holding a little black cat in her arms and singing: "I've got a little cat/I'm very fond of that."

There was a great fashion for anything and everything British at the time, and Belfort captivated her audiences when she sang old Irish melodies with the air of an angelic little girl. Lautrec recorded this idyll in a series of six lithographs, featuring the Irish girl dressed like a baby in a beribboned bonnet and holding her tiny pet with its curly tail.

May Belfort, widely known to be a lesbian, lived with an English dancer called May Milton, who had come to Paris with a troupe of girls. Lautrec

met the latter through Jane Avril and, showing his customary penchant for redheads, was instantly seduced by the splendid head of hair of "Miss Aussi," as he called her. This young woman appeared on stage for only one winter, but she was nonetheless immortalized twice over: Picasso's 1901 painting *The Blue Room* shows one of Lautrec's posters of May Milton hanging on the wall.

A beautiful stranger aboard ship (1895, below left) was the model for Lautrec's lithograph (1895, below right), her fine figure rendered by an assembly of lines and areas of flat color.

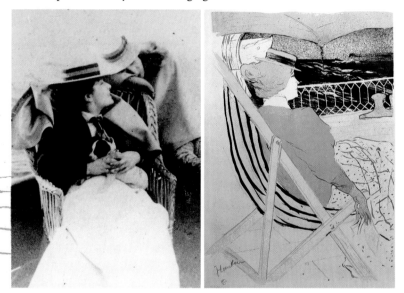

The Enigmatic "Passenger in Cabin 54"

Reticent by nature, Lautrec rarely let any amorous feelings show in his female portraits. In the summer of 1895, however, while traveling, he fell madly in love with a mysterious stranger—the wife of a colonial officer—aboard the ship *Le Chili* on the voyage between Le Havre and Bordeaux. Her cabin number was 54. He insisted on following her to Lisbon and even wanted to go on to Dakar, her ultimate destination. However, his companion, artist and photographer Maurice Guibert, forced

"She could be taken for a frog," said Maurice Joyant of May Belfort, the young Irish woman Lautrec used to take to the Irish and American Bar before her appearances at the Petit Casino. She had only limited success, despite Lautrec's fine lithograph of her (1895, opposite below) and her song and trademark: "I've got a little cat/ I'm very fond of that."

Edw Ancourt Paris

him to return to Bordeaux after brief visits to Madrid and Toledo, where Lautrec discovered the paintings of El Greco. This romantic, if unconsummated, adventure produced one of the artist's most striking lithographs, which was used as an advertisement for an international poster exhibition at the Salon des Cent that ran from October 1895 to March 1896.

Brothel Scenes

The end of the 19th century was the heyday of the brothel, subject of successful novels such as *La Fille Elisa* (*The Girl Elisa*) by Edmond de Goncourt, *Marthe* by Joris-Karl Huysmans, and *La Maison Tellier* (*The Tellier Brothel*) by Guy de Maupassant. Prostitutes also featured in paintings by Forain, Daumier, and Degas, not to mention Lautrec, who was happy to inhabit establishments others only passed through. Now and then Lautrec would "disappear," leaving his studio on the Rue Tourlaque for the brothels of the Rue Joubert, the Rue d'Amboise, or the Rue des Moulins. He moved in, lock, stock, and barrel, for days or even months—as if taking a cure at a spa—and painted and drew.

When art dealer Paul Durand-Ruel, noted promoter of the

Lautrec stands with a model (left and opposite) in front of his canvases. He shocked his contemporaries by painting daily life in brothels (pages 96 and 97), such as the women playing cards or dealing with the laundryman.

In the Salon at the Rue des Moulins (c. 1894, left) conveys a strange calm: One corner is occupied by the red cushions of the divan; a wall of mirrors forms the background, with five women positioned diagonally and one seen from the back. Lautrec took more care in painting their faces and cheerless air than their bodies or poses.

Impressionists, asked to see Lautrec's studio, the artist received him in a brothel on the Rue des Moulins, surrounded by its residents. "I hear the word brothel on all sides," the artist wrote in feigned surprise, "but have never felt more at home." He took his intrigued and delighted friends —Romain Coolus, Maxime Dethomas, and Maurice Guibert—to houses respectable men generally visited incognito.

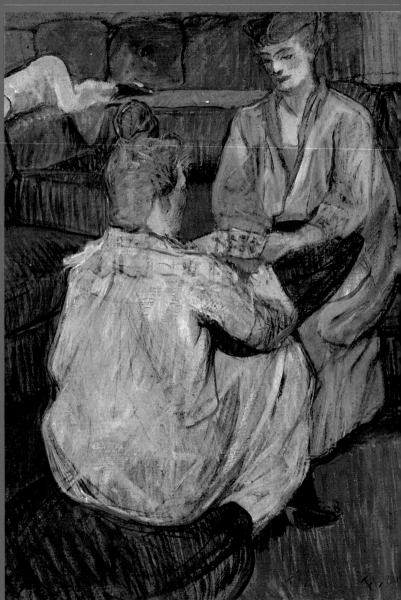

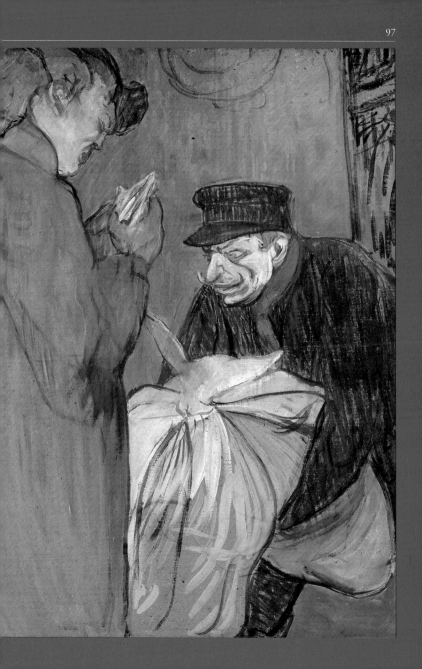

In 1892 the madam of a brothel on the Rue d'Amboise commissioned Lautrec to paint sixteen huge canvases for the walls of the main reception room. Lautrec completed two panels himself, finishing the others with the help of a local housepainter and a pupil of Puvis de Chavannes. The canvases were cut into pieces and sold shortly after World War I.

Some of the brothels were lavishly furnished and decorated by well-known artists. One of these was Le Chabanais, an internationally known establishment offering Oriental and Japanese suites, where members of the fashionable Jockey Club used to go. The words "house of all nations" were displayed in the entrance hall. The Japanese room in a brothel on the Rue des Moulins won a prize for its decoration at the Universal Exposition of 1900.

In 1896 appeared Lautrec's album *Elles,* a series of lithographs of prostitutes aimed at a male public—evoked by the top hat on the frontispiece (above).

Elles, Courtesans and Models

Like Baudelaire's volume of poetry *Les Fleurs du Mal,* published in 1857, which included several poems deemed obscene by the critics, Lautrec devoted an entire album of lithographs to prostitutes. The album, *Elles,* appeared in 1896 and consisted of ten plates, untitled, unnumbered, and in no particular order, half of them printed in color, the rest in green or rose on a tinted background. Unlike the album of Cormon's pupil, Bottini (*Bals, Bars et Maisons Closes,* published in 1899), *Elles* was not a success, and the publisher was obliged to sell the prints individually.

In Paris in 1890 a law against immoral commercial displays was passed. Some artists, such as Jules Chéret, supported the crusade for moral order. Lautrec ignored it. Merely entertained by the campaign against pornography, he continued to paint and engrave as inspiration took him, using as his models the prostitutes whose daily lives he so happily shared.

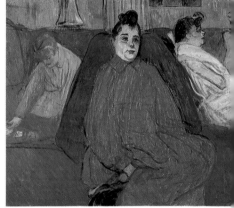

The theme of the courtesan permeates the history of Western art. But no one before Lautrec so strongly conveyed the tragic cynicism of *In the Salon: The Divan* (1893–4), in which the prostitutes await their customers with the resignation of the condemned.

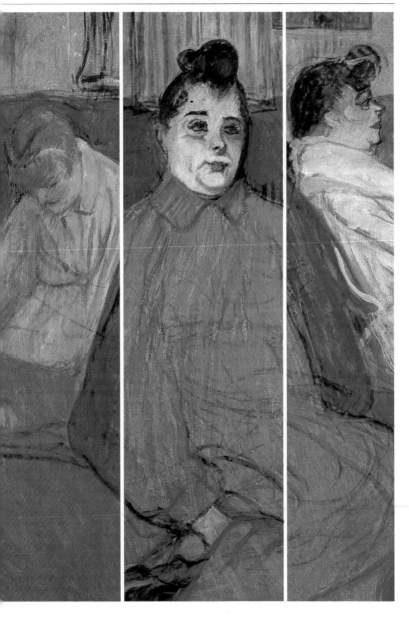

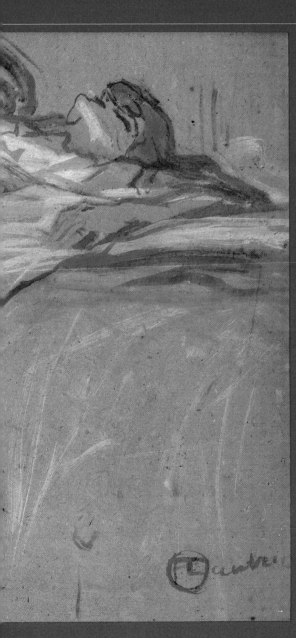

The pictures in *Elles* are a dazzling exercise in lithographic technique: monochrome and multicolored inking, decorative areas in flat tints, curving and counter-curving lines. The newspaper *La Plume* acclaimed the album, published by Gustave Pellet, as a work "of a brilliantly cruel exactitude." In some cases a simple drawing was the only preparation for the lithograph. In others, such as *Woman Combing Her Hair* (above) and *Lassitude,* Lautrec first prepared large oil sketches with the impact of full-scale paintings. The study for *Lassitude* (left), painted in heavily diluted oil, shows exceptional graphic skill. Before embarking on the laborious work of engraving, Lautrec allowed himself free reign with the brush. *Lassitude* was the tenth and last print in the album.

Lautrec owned a small volume of reproductions of erotic engravings, which he delighted in showing to select friends, watching their reactions with wicked delight.

He had been much inspired by the engravings of the great Japanese artist Kitagawa Utamaro, who, in *Twelve Hours in a House of Ill Repute,* portrayed the activities of courtesans throughout a day in the brothel. Goncourt had published a book extolling Utamaro in 1891, the year of an important exhibition of Japanese engravings at the Ecole des Beaux-Arts. Durand-Ruel put on an exhibition of the engravings of the Japanese master in 1894.

Love Between Women

In the world of the *café-concerts,* notably in the little bars of Montmartre—La Souris and Le Hanneton—and also in the brothels, lesbian love was a common occurrence. Lautrec encouraged these Sapphic inclinations, finding artistic inspiration in the poses of female lovers. The sight of two sleeping women entwined on a bed prompted him to say: "This is superior to everything. Nothing can compare to something so simple." Like Baudelaire, he dared tackle the subject of forbidden love,

The intimacy of *In Bed* (above) and *The Kiss* (below), both painted by Lautrec in 1892, almost makes the viewer feel like a voyeur.

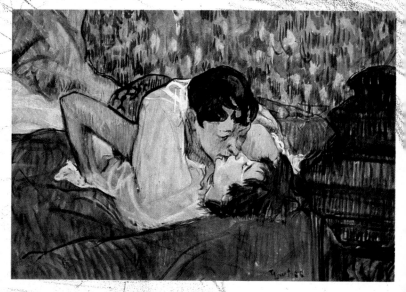

which he portrayed in several paintings.

As Degas did with his monotypes, Lautrec stands out in his time as the artist who went furthest in his portrayal of subjects that shocked bourgeois morality. In 1893 alone he produced eleven canvases featuring female lovers. Five were used as illustrations for an

While *Woman in Bed—Waking* (1896) resembles a drawing, it is in fact one of the lithographs in the *Elles* series.

article by Gustave Geffroy entitled "Pleasure in Paris" printed in *Le Figaro Illustré*. He returned to the subject in 1894 and 1895—in paintings such as *The Two Friends* (1894) and *The Kiss* (1895)—when he spent a year in a brothel on the Rue des Moulins, the establishment about which he commented: "I don't like just dropping in there." This moral freedom and disregard of taboos made Lautrec the spiritual precursor of Picasso. The latter, particularly in his engravings, showed he had assimilated the lessons of his predecessor and, like him, did not hesitate to exceed the accepted norms in his portrayal of the varied aspects of love.

French painter Gustave Courbet (1819–77) began to portray female lovers in 1860. In Lautrec's time lesbian scenes were a common subject of pornographic photographs, clandestinely exchanged.

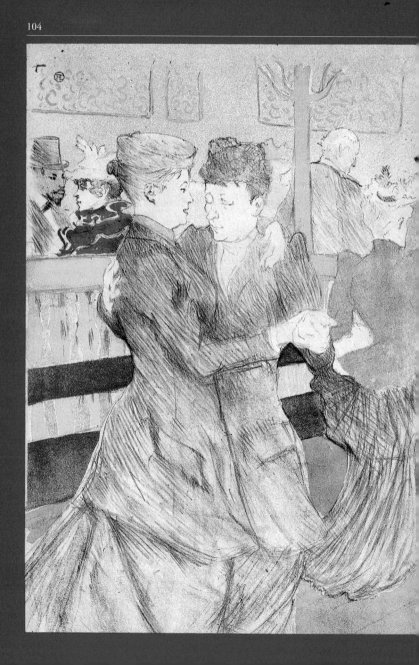

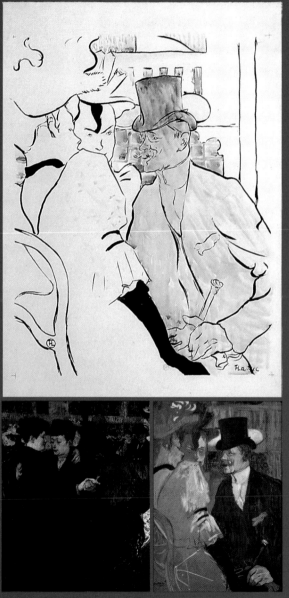

Far from being definitive works of art, many of Lautrec's pictures were preparatory studies for engravings or illustrations. A case in point is *The Englishman at the Moulin Rouge* (1892): An oil and gouache painting on cardboard (below right) preceded the lithograph touched up with blue watercolor (left), which was followed by the final print. Lautrec here portrays the English painter William Tom Warrener, a former pupil of Gustave Boulanger and Jules Lefèbre at the Académie Julian. It was probably through the painter Charles Conder that Warrener came into contact with Lautrec and became a "keen admirer." Charles Conder is sitting in the background on the right in *At the Moulin Rouge: the Waltzers* (1892, below left), while Cha-U-Kao dances with a young woman, and Jane Avril, seen from the back, leaves the floor. On the left is another of Lautrec's friends, painter François Gauzi. Done some five years after his painting, the lithograph *Dancing at the Moulin Rouge* (1897, opposite) blurs the figures, which seem to float like ghosts.

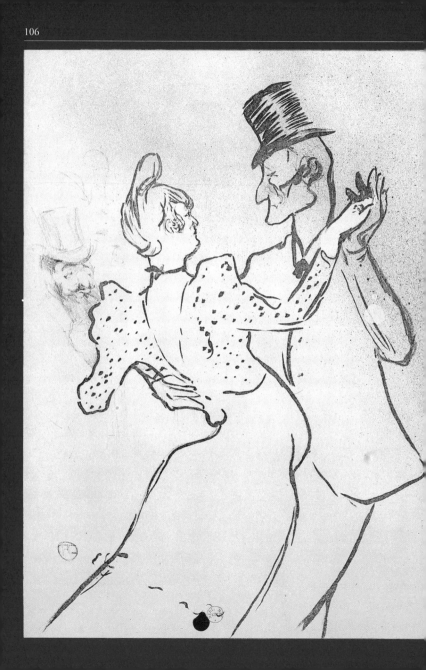

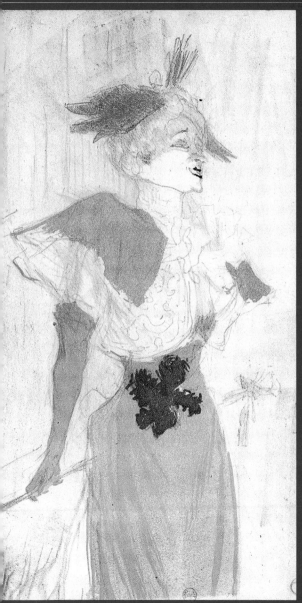

The splendor of his models and his fascination with their gestures sometimes distracted Lautrec from his habitual love of color, and he would produce a work of art that was monochrome but in no way diminished in power or effect. When La Goulue and Valentin le Désossé danced together "with stirring grace," as Maurice Joyant put it, Lautrec captured their movement with utter naturalness. Starting with a preliminary drawing, he progressed to the sensual caricature seen in the lithograph opposite. An edition of fifty copies was printed in 1894 in black or olive green, and a later, larger edition was used as the cover of the score of a waltz by the publisher A. Bosc. Lautrec, who so loved to watch Marcelle Lender's back during performances of *Chilpéric*, never displayed more than three-quarters of her face in his portraits. In 1895 he featured her in a major series of sumptuously colored lithographs and did another, very delicate, one of the young woman (left) that aptly conveys her elegance in its khaki coloring, while the red flower at her waist suggests her seductiveness.

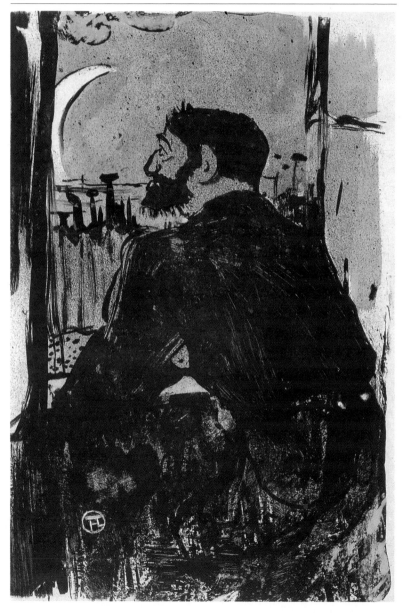

Lautrec's health began to deteriorate in 1898, and he became less and less productive. Such were the ravages of alcohol that his family was obliged to confine him to a mental hospital. He left after a few months, in a pitiful state. Suffering from paralysis of the legs, Lautrec died on 9 September 1901, at the age of thirty-six, in the arms of his mother, Adèle.

CHAPTER V
"I AM CONFINED, AND ALL CONFINED THINGS DIE"

"I still remember my first visit to Lautrec, the very first, and my agonizing sadness. At the end of a narrow, low, corridor lit by observation holes and ending in a low door, in two little square cells, with barred windows, one being his room, the other the keeper's, a calm, lucid Lautrec, already at his pencils and drawings, welcomed me like someone setting him free."
 Maurice Joyant, 1899

"Dear Sir, I feed on nux vomica [a seed from which strychnine is made]: thus Bacchus and Venus are kept away. I paint and I even sculpt. If I get bored, I write poetry.
Yours, H."
 Letter to Maurice Joyant
 2 April 1901

Opposite: *Sleepless Night,* an 1893 colored lithograph.

The Ravages of Alcohol

In the late 1890s Lautrec painted less and less, preferring simply to wander between bars and cabarets. In the words of his friend Thadée Natanson, when in the grip of alcohol Lautrec never stopped "hiccuping with laughter. Drunk, he laughed till he cried. Brief rages, but laughter predominating." His behavior was deeply disturbed. He was prey to attacks of delirium. As early as the summer of 1897, while staying with the Natansons at Villeneuve-sur-Yonne, he had fired a revolver at imaginary spiders. In the autumn of 1898 he showed symptoms of serious

"On the pretext of showing them recent paintings and drawings, one of our youngest masters invited his close friends to come and have a cup of milk in his studio this week.…
In a small room, all 'just so,' a barman in starched white uniform quietly prepared cocktails that were downed by florid frock-coated men, leaving

instability. Once, in the open street, he became convinced that the police were pursuing him and had to take refuge with a friend. A few months earlier Maurice Joyant had organized a retrospective

the over-frugal rustic repast to the ladies.…
We happily drank, sang, played the flute, rolling up in our fingers the lithograph sent as an invitation, in which a splendid cow promised a novel kind of summer festivity."
La Vie Parisienne

exhibition of Lautrec's work at the Goupil gallery in London that proved far from successful. The English were voluble in their criticism, and at the opening, which was graced by the presence of the future Edward VII, Lautrec himself fell asleep—a clear sign of physical and mental deterioration.

The previous year had augured well. Lautrec had moved again, leaving the Rue Tourlaque for a charming villa surrounded by trees on the Avenue Frochot. Several of his works were lost in the move; the next tenant used them to fill holes in the ceiling. The artist's carelessness with his work was the more surprising because orders were pouring into the Goupil gallery. An exuberant housewarming featuring glasses of milk was held in the new studio. The invitation portrays an animal tamer brandishing his whip at a cow with bursting udders.

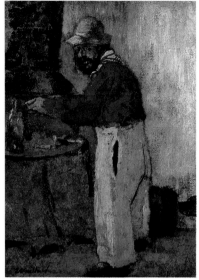

5 avenue Frochot ... sera très fâché si vous voulez ... tasse de lait le Samedi 15 Mai ... après midi

Confinement

To curb Lautrec's excessive drinking, his family hired a keeper to look after him. On 17 March 1899, after a violent attack of alcoholism, he was sent to a clinic on the Avenue de Madrid at Neuilly. Recovering to find himself in a locked room, he wrote to his father: "Papa, this is your chance to do the decent thing. I am confined,

In 1898, when they were both staying at Relais, the Natansons' estate at Villeneuve-sur-Yonne, Vuillard surprised Lautrec and painted the above portrait of him. The strident colors, unusual in Vuillard's work, suit the subject, whose furtive look is captured with great vividness.

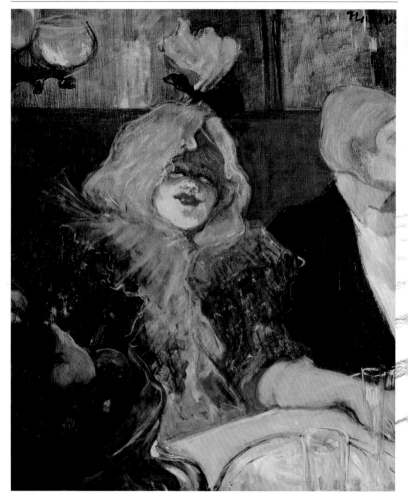

and all confined things die." Lautrec's doctor friends, Henri Bourges and Gabriel Tapié de Céleyran, had convinced his mother—against Maurice Joyant's advice—that he needed to be locked up for a compulsory detoxification.

Controversy about Lautrec's condition broke out in the press. His supporters and detractors clashed. But the scandal made him only more of a celebrity and increased

In this painting, *In a Private Room at the Rat Mort* (1899), Lautrec captures the atmosphere of the luxurious private dining rooms in one of his favorite restaurants.

the demand for his work. He became contentious. On 17 May he left the asylum, having produced a book of sketches on circus subjects. Joyant decided to publish it in an attempt to revive the artist's zest for life and work.

Nostalgia for the Circus

There was now no great gap between the madness by which he was surrounded and the clowns he was drawing. His sketchbook *Le Cirque* is one of Lautrec's last masterpieces, a perfect example of graphic elegance: the female clown Cha-U-Kao, the clown Footit (this time without his stooge Chocolat), the poodle, the equestrienne, the lion tamer… With dazzling virtuosity

During his confinement at the clinic in Neuilly, Lautrec was deprived of alcohol and kept under constant surveillance by his nurse, Pierre, who is portrayed in *My Keeper* (1899, above).

of line, Lautrec brought to life the imaginary companions of his confinement, confiding to Maurice Joyant that he had purchased his freedom with his drawings. After his release Lautrec lived with Paul Viaud, a friend and distant

The drawings Lautrec executed from memory in the clinic—particularly those on circus subjects —were a crucial ploy: He hoped that he would be released if he showed he could still draw.

Lautrec was a regular visitor to the Cirque Fernando (the future Médrano). At the clinic in Neuilly, in 1899, he made a series of drawings of the circus that look as if they had been done from life and brilliantly capture, in their lines and colors, both the comic and the poignant quality of their subjects. The spectators' seats are empty, however: It is the performers alone who merit the artist's attention, as seen in these drawings of a clown, horse, and monkey (opposite) and the female clown Cha-U-Kao in the role of circus equestrienne (left).

Overleaf: Remembering the Jardin de Paris, Lautrec drew a tightrope walker about to set out along a rope stretched over the trees of the Champs-Elysées (page 116); an equestrienne, still in her mules, waits in the wings before entering the ring (page 117).

relative from Bordeaux. This big sporty fellow, unable to touch a drop of alcohol because of a stomach complaint, was his appointed keeper. Lautrec was under constant surveillance, and his family strictly controlled his finances by giving him a basic monthly income, which he supplemented by selling his canvases through his agent, Maurice Joyant.

In these years Lautrec's behavior was often startling: He could be seen in the street wearing red trousers and sporting a blue umbrella, carrying an earthenware dog under his arm, or trailing a cardboard elephant.

The only sport Lautrec was able to engage in was swimming, which he greatly enjoyed. In this photograph (c. 1899, left) he is on a boat trip with Paul Viaud.

In July 1899 Lautrec went to stay at the Hôtel de l'Amirauté in the coastal town of Le Havre, chaperoned as usual by Paul Viaud. The considerable maritime traffic had led to the proliferation of bars and *café-concerts*, which were frequented by British sailors and featured artistes from across the Channel. The model for *The English Girl at the Star in Le Havre* (opposite, in oil on wood and, to its right, the study in red chalk, both made in 1899) was, according to Maurice Joyant, a singer called Miss Dolly. In July 1899 Lautrec wrote to Joyant: "Yesterday I sent you a registered packet, a panel of the head of the barmaid at the Star. Let it dry and frame it."

In 1901 Lautrec painted a portrait of his companion Paul Viaud in the uniform of an 18th-century English admiral (left). The picture was intended to hang above a mantelpiece at Malromé, his mother's home. The free brush strokes and the depth of the red show that Lautrec was experimenting until the end of his life. This portrait, never finished, remained at Malromé until the death of Countess Adèle.

Eager to leave Paris, Lautrec first went to Le Crotoy and then to Le Havre, where he regained his zest for painting after meeting Miss Dolly, the barmaid at a *café-concert*. Blonde, pretty, and English, she inspired him by reviving memories of days in Paris, not long past, when he had moved freely from café to café. On 20 July 1899 Viaud and Lautrec left for Arcachon, as was their custom at that time of year, and then went to stay with the painter's mother at Malromé in time for the grape harvest. By October Lautrec was back in Paris.

Last Stay in Paris

Finding it too difficult and exhausting to walk, Lautrec turned for help to his neighbor on the Rue Fontaine, whose business was leasing vehicles. The man found him a tiny tilbury pulled by a pony and accompanied him on his last drinking bouts. In his work Lautrec returned to the equestrian themes of the early years, realizing one of his finest lithographs, *The Jockey* (1899), which portrays the horses and riders from the rear at a strikingly apt and lifelike angle.

Lautrec shared a very modern passion for the motor car with his cousin Gabriel Tapié de Céleyran. In 1898 he portrayed him at the wheel of what looks like a racing car, muffled in furs and protected by goggles, speeding past the delicate silhouette of a woman walking her dog.

He also designed a poster, the last to feature Jane Avril. The singer is seen from the front, her arms in the air, a boa twisted around her. Avril's manager rejected the poster, although she herself was pleased with it.

From 1898 to 1899, his interest in sport having been revived, Lautrec went to horse races with his friend Tristan Bernard, a veteran racegoer. *The Jockey* (1899, opposite) was the first of a series of four color plates on racing subjects commissioned by the publisher Pierrefort.

Speed of a more modern kind: Lautrec's cousin Gabriel Tapié de Céleyran was the model in this lithograph, *The Motorist* (below left), dated 1898. Lautrec's penultimate poster was of Jane Avril (1899, below).

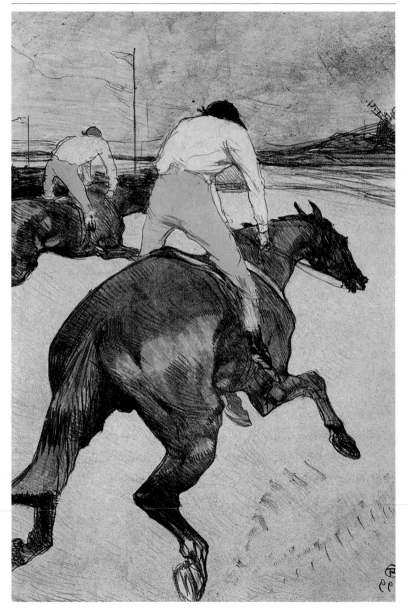

Afinal expression of affection for his childhood friend, Lautrec's 1900 portrait of Joyant (below) was based on this photograph of him on a fishing

expedition around 1899. Joyant did at least seventy-five sittings for the painting.

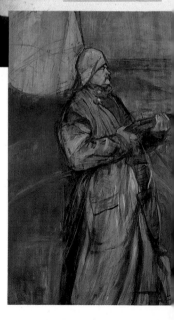

A few weeks later he completed his last poster, an advertisement for Jean Richepin's play *La Gitane,* starring Marthe Mellot, whom he had also portrayed in 1897.

Meanwhile, Lautrec was enjoying a final dalliance with Louise Margouin, a milliner whose charms were celebrated in a poem by Lautrec's great friend Romain Coolus. Joyant related that Lautrec's friends, anxious to keep him from drinking and eager to amuse him, took him around the couture houses on the Rue de la Paix. Louise Margouin, whose name is slang for "milliner," was in reality Louise Blouet, an employee of the dressmaker Renée Vert. Her magnificent head of Titian-red hair immediately caught Lautrec's eye: *The*

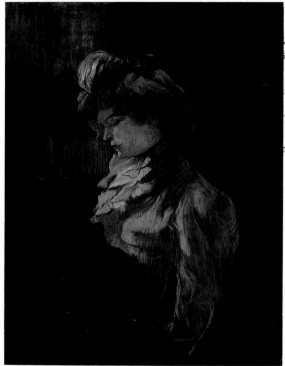

Milliner, painted on wood, is typical of the artist's late style in its studied contrast of the effects of light against a dark background.

Final Days

In the spring of 1900 the artist's health deteriorated still further. His family, hard hit financially by a flooding of their farms and vineyards, cut back his allowance, which he saw as a futile and unfair means of putting pressure on him. His amnesia assumed alarming proportions.

In mid May he returned to Le Crotoy, where he painted a portrait of Joyant in a yellow sou'wester on board ship.

At Honfleur Lautrec's friend the actor Lucien Guitry commissioned him to design and illustrate a program for a play based on Zola's novel *L'Assommoir.*

This drawing of a dressmaker (above) was one of a series, including a lithograph, on the subject done by Lautrec in 1893. The model was Renée Vert, companion of his old friend the painter and engraver Adolphe Albert. In 1900 Lautrec returned to the subject, using Louise Margouin as his model (left).

"She was a young milliner with a splendid head of fair hair and the fine features of an alert squirrel.… His feelings toward his women friends were a curious blend of jolly camaraderie and repressed desire."
Paul Leclercq

Lautrec resting in the garden at Malromé in the summer of 1900, with his mother, Countess Adèle.

After three months of bathing in the sea at Arcachon, Lautrec enjoyed a few weeks' rest with his family at Malromé before leaving for Bordeaux. There he remained until April 1901, in a studio taken over from the art gallery Imberti.

Working frenziedly, Lautrec produced two series of paintings inspired by performances of *Messalina,* an opera by Isidore de Lara, and *La Belle Hélène,* by Jacques Offenbach, which were both performed at the Grand-Théâtre in Bordeaux. Well aware of his friend's total exhaustion, Joyant suggested a major retrospective

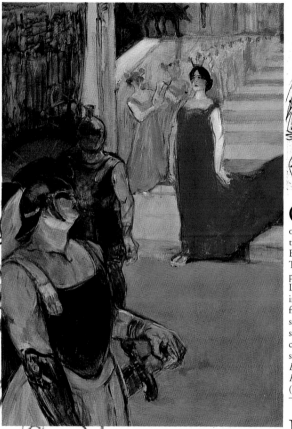

exhibition of his work to restore his spirits. Lautrec enthusiastically agreed and spent a hundred days in his Paris studio feverishly reworking, perfecting, and sorting, finishing some sketches and eliminating others, as if driven by a need to leave everything in order, as if time were running out. He put his

On 14 December 1900 the French premiere of *Messalina* was held at the Grand Théâtre de Bordeaux. Enraptured by Thérèse Ganne, who played the title role, Lautrec shut himself up in his studio and produced first sketches and then a series of paintings that he sent to Joyant with the comment: "I am very satisfied." Left: *Messalina Descending the Staircase Flanked by the Chorus* (1900–1).

Lautrec also drew Cocyte playing Hélène (left center).

At the end of 1900 Lautrec heard violinist Jean-Charles Dancla, a recognized virtuoso and composer of many pieces for violin. Lautrec painted his portrait after making a few preliminary drawings, one of which is above.

initials on anything he deemed worthy of his signature. And in July he painted his last canvas, *An Examination at the Paris Faculty of Medicine,* in which his cousin Gabriel Tapié de Céleyran is shown at his oral examination for a doctorate in medicine. Lautrec then abandoned Paris for Arcachon, leaving his studio in impeccable order. In mid August, after suffering a severe attack of paralysis, he left Arcachon to join his mother at Malromé. He died in her arms on 9 September 1901, at the age of thirty-six.

Passage to Immortality

Acclaimed in his lifetime as a poster designer and illustrator, it was not long—only a few years after his death—before he became famous as a painter, thanks largely to the untiring efforts of his friend and dealer Maurice Joyant.

In 1902 Joyant organized the first retrospective exhibition at the Durand-Ruel gallery, where Lautrec's paintings were sold for considerable sums. In 1914 the Rosenberg gallery put on an even more comprehensive exhibition, which made Lautrec's work known to a wider public. In 1904 Bonnat—Lautrec's old teacher, and by then chairman of the Trustees of the National Museums of France—opposed the acquisition by the Musée du Luxembourg in Paris of Lautrec's portrait of Léon Delaporte, a director of an advertising business in Montmartre. Joyant suffered several rejections by the state, to which he would have liked to leave Lautrec's canvases. However, he succeeded in persuading the

Through his friend Dr. Henri Bourges and his cousin Tapié de Céleyran, Lautrec came into contact with the medical world. "If I weren't a painter, I'd like to be a doctor or surgeon," he told Joyant.

Lautrec had, as far
back as 1891,
portrayed the famous

Dr. Jules-Emile Péan
performing a
tracheotomy. Two years
after his cousin Gabriel
Tapié de Céleyran
underwent his oral
examination for his
doctorate in medicine
Lautrec painted the
occasion, which he had
been unable to attend
because of his
confinement at Neuilly.
He treated this last work,
*An Examination at the
Paris Faculty of Medicine,*
with deliberate dramatic
intensity, using dark
colors and applying the
paint thickly. It has the
appearance of a court of
law. Although he
modeled the jury on old
friends, Lautrec may have
been remembering his
recent experiences with
the medical staff of a
Paris mental clinic, where
he felt he had undergone
an inquisition.

Consul General of Tarn to establish a museum devoted
exclusively to the work of Lautrec in the magnificent
Palais de la Berbie, the former episcopal residence of the
bishops of Albi. This was opened in 1922 by the French
Minister of Education and Fine Arts, Léon Bérard—
belated but nonetheless public and national recognition
for the work of a physically handicapped aristocrat who
revolutionized the relationship of artist and model.

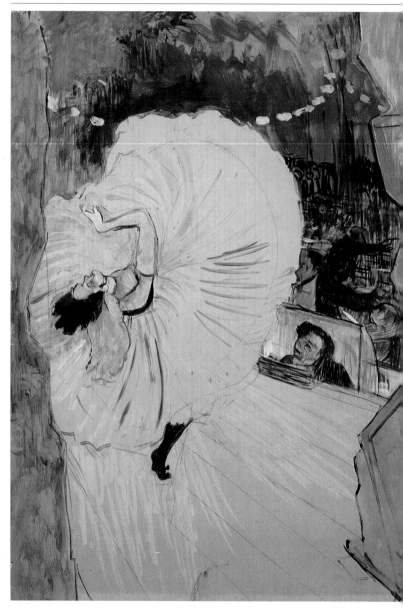

DOCUMENTS

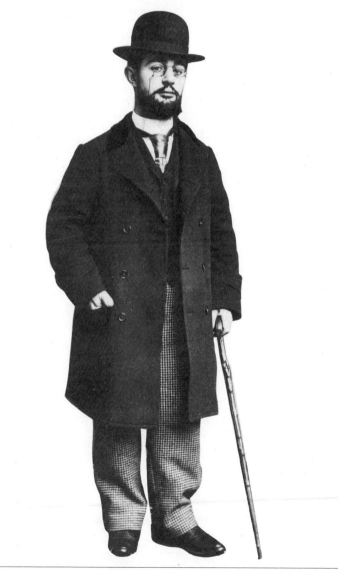

Fragments of a Life

Whether in letters to his family and friends—incorporating drawings and amusing anecdotes—or in his business correspondence, Lautrec revealed little of his personality. It was only to his mother that he expressed himself openly, and with tremendous affection, declining to mention details that might have offended her moral sense.

The numbers of the letters quoted refer to The Letters of Henri de Toulouse-Lautrec, *edited by Herbert D. Schimmel (1991), unless otherwise stated.*

Grandmothers, Cousins, and Family Pets

Between 1871 and 1877 Henri wrote regularly to members of his family in the Albi region, such as—here—his paternal grandmother and the sister of his maternal grandmother, Gabrielle d'Imbert du Bosc, widow of Raymond-Casimir de Toulouse-Lautrec. His concerns were those of a child, and he already showed anxiety about his health.

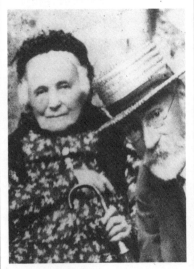

Lautrec's paternal grandparents (above) and his mother (opposite).

Paris, 30 December 1872

My dear Grandma,

I am awfully glad to be sending you this letter, for it is to wish you a happy and prosperous New Year. I am anxious

to be back at Bosc [her property at Naucelle near Rodez] for my holiday, although I don't mind it here in Paris. We are on holiday right now, and I am trying to have as much fun out of it as I can. Too bad I have pimples that make me lose a lot of time scratching. Please tell Aunt Emilie that my little canary Lolo sings very well, he is awfully nice. I have bought him a very pretty cage with my New Year's gift.

Goodbye, dear Grandma. I kiss you with all my heart, my Aunt Emilie, my Uncle Charles, and my Uncle Odon as well, and please accept, all of you, my best wishes for a happy New Year.

Your respectful grandson, Henri
[Letter 4]

Separated from his mother, Henri began a life-long correspondence with her.

[Paris, 19 June 1873]
My dear Mama,

When I was asking you to stay, I had no idea of the pain that a person feels when he is leaving his mama; I call out for you constantly and would be very happy to see you again.

All the same, you can be sure that I'm working as hard as I can, to please you. Today I'm stuck in the house because of the rain. M. Lévi sends you his regards. I'm alone with the Lolottes [his canaries] in the bedroom, since I didn't finish my homework, and am very sorry that I'm not with you. I didn't have time to write English. Yesterday evening the son of Mme. Michel, on orders from M. Mantoy [Lautrec's first teacher at the Lycée Fontanes], threw me against the bars that support the flight of stairs at the Lycée. I complained to his mother, who ordered him punished. In the morning we went to High Mass.

Goodbye, my very dear and beloved Mama.

Your dear pet, H. de T. Lautrec
[Letter 7A]

Cousinly Love

Henri was particularly fond of his cousin Madeleine Tapié de Céleyran, who died young in 1882.

[Paris, January 1874]
My dear Madeleine,

I hasten to answer your very well-written letter. You made me think about myself and I am ashamed of scribbling as I do. I am anxious to be having a good time with you all in the Gravasse [the forest near the Château du Bosc] or the big driveway at Céleyran…. I would like very much to go walking with you on the boulevards,

where there are so many dolls you wouldn't know which one to pick. Please thank my godmother and aunt Alix for me for their nice letters.

Goodbye, dear cousin, I wish you happy New Year, sending you all my love, and ask you to do as much for me with all the others.

Your cousin who loves you very much,
Henri de T. Lautrec
[Letter 9]

"I Am Awfully Tired of Limping"

More than a year before his first accident, Henri told his paternal grandmother about the trouble he had with his legs.

Paris, 1 March [18]77
My dear Grandma,

…I have more free time just now because Mama has taken me out of the professor's classes [Lautrec had left the Lycée Fontanes in January 1875 because of ill health, and probably had a tutor] so they can give me the electric brush treatment [probably a type of massage used to increase the circulation in his legs] that once cured my Uncle Charles. I am awfully tired of limping with my left foot now that the right one is cured. Hopefully it's only a reaction after my treatment, so Dr. Raymond says; I already feel better. We are definitely going to take the waters in the Pyrenees this year, won't you come there with us?…

Your respectful grandson,
Henri de T. Lautrec
[Letter 23]

1878-9, a Year of Accidents

Henri had ample time to tell his family and friends about the misfortunes that left him crippled for life. Here he writes to his cousin Raoul Tapié de Céleyran.

Albi, 22 May [1878]
My dear Raoul,

I have to call upon my mother for help in order to write to you, and, believe me, this is not easy or pleasant. As you've been told, I broke my left leg. They've tied me up in an apparatus, and all I have to do is be still. In this way my leg doesn't hurt.… Give my love to everybody, and especially to my little Finet [the dog], along with some good advice about not breaking his little paw.

Your cousin, Henri—Broken-Paw!!!
[Letter 27]

Lautrec wrote to his godmother, Madame Louise Tapié de Céleyran, from Barèges, the spa where he had been sent to recuperate from a broken leg. He attributed the accident to his own clumsiness.

[Barèges, August–September 1879]
My dear Godmother,

I am sure you will be pleased to hear that I am as well as can be expected and that I have no pain. I'm not too bored either, and hope you won't fret too much about my case because a clumsy fellow like me just isn't worth it.… The doctor is delighted at the prospect of a cure.… Goodbye, my dear Godmother. I kiss you as best I can and please give my best to everybody.…

Your clumsy godson,
Henri de Toulouse
[Letter 43]

"The Surgical Crime"

Lautrec confided in his friend Etienne Devismes, whom he had met in 1878 at Barèges, where they were convalescing.

[Barèges, September 1879]
…The surgical crime was consummated on Monday, and the fracture, very

admirable from the surgical point of view (not from mine, needless to say), was brought to light. The doctor was delighted and left me in peace until this morning. Then this morning, using the deceptive pretext of getting me up, he made me bend my leg at a right angle, thereby causing me atrocious suffering.

Oh, if you were here just five little minutes a day, I'd feel as if I could face my future sufferings with serenity....

Your devoted
Henri de Toulouse-Lautrec
[Letter 44]

A Humorous Self-portrait

He made fun of himself in a letter to his great-aunt Joséphine du Bosc.

[Céleyran (1879)]
My very dear Aunt,

Look at that shape absolutely totally lacking in elegance [in his self-portrait], that big behind, that potato nose.... He is not good-looking, and yet, after knocking at the door, and without stopping when Flavie the concierge cries out in astonishment...it climbed the stairs as fast as its legs (broken twice, poor legs!...) allowed him....

H. de T. L.
[Letter 46]

1881, a Change of Tone

Lautrec failed his baccalauréat in 1880, but managed to pass it a year later. More important, however, was his decision to become a painter. He dedicated his Book of Zigzags to his cousin Madeleine Tapié de Céleyran. It was an illustrated commentary on his stay in Nice.

Nice, January 1881
...Dear cousin, please forgive me! Laziness, and more particularly bad weather, kept me from writing!! Rain, ping, ping, slush, mud, botheration, our eternal Father munificently bestowed it all upon us. Disgusting, isn't it?

[Letter 56]

"I Get as Inflated as a Gambetta Balloon..."

Henri recounted his first artistic projects to his Uncle Charles de Toulouse-Lautrec, who had always encouraged his interest in painting.

Paris, Saturday [May 1881]
Prophet!!!! Prophet!!!!

Dear Uncle, rival of Mohammed, you predicted a chestnut foal, and lo and behold, it's happened. My compliments to you, along with my hope that "mother and child are doing well," as the saying goes.

What studies in perspective.

I also wanted to write to you about my foal, because I have one: my palette. I get as inflated as a [Léon] Gambetta balloon [an allusion to the time in October 1870 when the French statesman escaped in a balloon from the Prussians, who had surrounded Paris] when I think of the compliments I've received on it. All joking aside, I was flabbergasted.

[René] Princeteau was ecstatic, [the painter and sculptor Vicomte Charles-Marie] du Passage cried, and Papa was completely bewildered. We thought of everything, we even dreamed of [Emile-Auguste] Carolus-Duran.

Anyway, here is the plan that I think offers the best chance of success. Ecole des Beaux-Arts, [Alexandre] Cabanel's studio, and attendance at René's studio. I did a portrait of [his cousin] Louis Pascal on horseback. Well. I'm carrying on, and I hope you'll be pleased, since you're the one who lit the sketching spark in me....

Everything's fine. Goodbye, until we meet at Le Bosc under the umbrella and on the folding chair.

What rapid sketches!!!!!

Your nephew Henri
[Letter 59]

"I Tried for Truth Rather Than the Ideal"

Lautrec's friend Etienne Devismes sent him the manuscript of Cocotte *(illustrated below), an account of the misadventures of an old army horse that ends its days with a worthy country priest.*

Lamalou-les-Bains [August 1881]
Dear Friend,

...I didn't receive your gem of prose until the day before yesterday. Here I am in a horrible hole of red earth, but the landscapes will be all right for Bagnols. I'm going to get down to work, but I'm anxious to collaborate with you on your story. It's really too good of you to have taken a look at my paltry pencil, which will do whatever it can do, you can rest assured of that; however, I hope to do something on the subject of *Cocotte.* I'll try to be quick....

H. de Toulouse-Lautrec
[Letter 61]

Lautrec wrote to Etienne Devismes again later in the same year.

Hydropathic Establishment of
Lamalou l'Ancien [Hérault]
[October 1881]

My dear Friend,

I worked as well as I could, and am sending you by the same mail 23 drawings, including two copies of one because of an accident. They're rough sketches and perhaps a little too mirthful, but it seems to me that the text is equally so. The poor priest! Since I'm completely at your disposal, write to me if you want changes made, and if you wish send me back the ones you are not going to use. If you'd like new drawings, I'm your man, because I'm so happy you took a look at my crude inspirations....

I tried for truth rather than the ideal. This may be a mistake, because I don't look with favour upon warts and I like to decorate them with playful hairs, make them round and give them a shining tip.

I don't know whether you have control over your pen, but when my pencil is moving I have to give it its head or crash!... dead stop.

Well, anyway, I've done what I could, I hope you'll be lenient. Wouldn't it be wonderful if...but one shouldn't count one's chickens before they're...

Farewell, I send you my warmest regards. Please give my respects to your mother, and my good wishes to André (has he come by?).

A budding painter,
H. de T. L.

P. S. Please drop me a line quickly. Am excited.

[Letter 64]

Preliminary sketch for *Young Routy at Céleyan* (1882).

1882, Bonnat's Studio

Paris, 22 March 1882

My dear Uncle [Charles],

I'm keeping my promise to keep you up to date. By unanimous opinion, I'm going to visit [Léon] Bonnat on Sunday or Monday. [René] Princeteau is going to introduce me. I've been to see the young painter [Henri] Rachou, a student of Bonnat's and a friend of [the goldsmith] Ferréol [Roudat], who is beginning to work alone; he is submitting a painting to the Exhibition [the 1882 Salon].... More of my plans. I'll probably get myself admitted as a student at the Ecole des Beaux-Arts so that I can participate in their competitions while remaining with Bonnat....

Your nephew, H. de Toulouse

[Letter 71]

A fragment of a letter from Lautrec to his grandmother, Madame R. C. de Toulouse-Lautrec.

Paris, 6 April [1882]

…[René] Princeteau took me to see [Léon] Bonnat on Tuesday, 26 March. I brought along two or three daubs, including a picture of Germaine sucking her thumb [*Mademoiselle Tapié de Céleyran (Germaine)*]. The Master stared at the perpetrator and the work, and said to me, "Have you done drawing?" "That's the only reason I've come to Paris." "Yes," he said, "You have some sense of colour, but you would have to draw and draw." Whereupon he gave me his card and a note for the student in charge of his studio.… Princeteau is getting more and more friendly. As for me, I'm trying to get ready to work, because painting is definitely not a sinecure.…

[Letter 71A]

"A Thousand Small Kisses" for Mama, Respects for Papa

Henri did not easily adapt to separation from his mother and protested in 1882.

My dear Mama,

Have you broken your arm, or have you forgotten that your offspring exists? A brief word, if you will, to bring me up on what's going on.

Everything's fine here. I'm working hard. All the best and a thousand small kisses.

H.

Letter 41 from
Unpublished Correspondence of Henri de Toulouse-Lautrec,
edited by Lucien Goldschmidt and Herbert D. Schimmel, translated by Edward B. Garside, 1967

Henri appeared to write to his father only when he wanted his advice or needed his permission before making an important decision.

Le Bosc, this Thursday
[September 1882]

My dear Papa,

Bonnat has let *all* his pupils go. Before making up my mind I wanted to have the consensus of my friends and by unanimous agreement I have just accepted an easel in the atelier of Cormon, a young and celebrated painter, the one who did the famous *Cain Fleeing with His Family* at the Luxembourg. A powerful, austere, and original talent. Rachou sent a telegram to ask if I would agree to study there along with some of my friends, and I have accepted. Princeteau praised my choice. I would very much have liked to try Carolus[-Duran], but this prince of colour produces only mediocre draughtsmen, which would be fatal for me.

After all, I won't be married to the situation, will I? And the choice of teachers is by no means exhausted.…

Your respectful son, Henri
[Letter 76]

Studying Under Cormon

To his uncle Amédée Tapié de Céleyran…

[Paris,] Friday, 1 December [1882]

My dear Uncle,

…My new boss is the thinnest man in Paris. He often drops in on us and wants us to have as much fun as we can painting outside the studio.…

My most friendly regards and endearments to Dowager ladies and young ladies as well, meanwhile I shake your hand majestically by the forefinger.

Your nephew, H. Monfa
[Letter 80]

Writing to his paternal grandmother, he reports his change of studio.

[Paris,] 28 December [18]82

My dear Grandma,

I'm going to…tell you about the various stages I've passed through on the road of art.

Did I lose anything when I switched from Bonnat to Cormon? I should be tempted to answer, "No." The truth is that while my new boss does not *yet* have the astonishing prestige of my old boss, he is contributing to my training all the freshness of his early illusions, a talent that bids fair to carry off the medal of honour for this year, and tremendous good will. With this one can go much further than I probably will. In any case, I devote myself all morning and afternoon to my brush. I also have to tell you about a little exposure of my own: I have a picture or at least a daub in Pau. So now I'm an exhibitor.

Your respectful grandson,
H. de Toulouse-Lautrec
[Letter 81]

1883–4, "I'm a Little Bit on Edge, and I Need a Lot of Willpower Conscientiously to Do a Drawing"

To his Uncle Charles again…

[Paris,] 10 February 1883

Dear Uncle,

…Well, I'm getting to know Cormon [*photograph, right*] better, he's the ugliest and thinnest man in Paris. All because of necrosis. People even say he drinks. Cormon's criticisms are much more lenient than Bonnat's. He looks at everything you show him and gives you a lot of encouragement. This will amaze you—but I don't like it as much! The fact is that my former master's lashes put some ginger into me, and I didn't spare myself. Here, I'm a little bit on edge, and I need a lot of willpower conscientiously to do a drawing when something not quite as good would do just as well in Cormon's eyes. Still, in the past two weeks he has reacted and has expressed dissatisfaction with several students, including me. So I've gone back to work with vigour.…

Your nephew, H. de T.-Lautrec
[Letter 82]

Enthusiastically He Wrote His Mother a Letter, a Fragment of Which Remains

[Paris, April 1883]

Vive la Révolution! Vive Manet!

A photograph of Lautrec's teacher Fernand Cormon.

The breeze of Impressionism is blowing through the studio. I'm overjoyed, because for a good while I've been the sole recipient of Cormon's thunderbolts.

I spend my day working and my evening at [Baptiste] Pezon's [an animal act], looking at the wild beasts.

[Letter 85]

"Ruminations in the Sun"

In a letter to Eugène Boch, a studio colleague, Henri shows his concern about returning to work in Paris.

Château de Céleyran near Coursan [Aude]
[1 September 1883]

Dear Old Fellow,

…Before I get to Paris on 1 October I'd like to know whether Cormon has any sketching trips planned for then. Also, whether the studio is finished and ready to shelter our young brains all simmering with the ferments of inspiration. And whether the fellows are back, and which ones.…

I'll spare you the recital of my ruminations in the sun with a brush in hand and spots of a more or less spinachy green, pistachio, olive, or shit colour on my canvas. We'll talk about that later.

All the best, hoping for a few concise words from you to give me the lowdown on the situation.

The young rotter,
H. de Toulouse-Lautrec
[Letter 86]

1886–7, Art Student Turned Artist

[Paris, January 1885]

My dear Mama,

…I'm just about to be given a commission. I did a small drawing at

the Café Américain, and a journalist I know showed it to M. [Henri-Alexis de] Conty, the man who does the Conty guidebooks, and who is doing one on Nice and Monte Carlo. He liked the drawing, and I'm doing the flower festival for his guidebook [in the end Lautrec's drawings were not used]. Maybe this will be the lucky break I've been dreaming of.

Yours, Henri
[Letter 107]

Lautrec's letters increasingly refer to a lack of money, as in this one to his mother.

[Paris, late 1886]

…Things are going wonderfully for me and I am waiting for Bourges who has plans for sharing an apartment with me. We'll have to see. I've just written to Papa to ask for money. Would you please send me 300 francs as soon as possible, by registered letter, it's easier. I think that will be enough for the time being, but one can't be sure of anything…I'M GOING TO WORK HARD AND TRY NOT TO DRINK. Gentle Albert presents his respects to you, and as for me, I hug you as hard as the poor body allows me…

[Letter 134]

In this letter he writes to his paternal grandmother about his work and the disapproval of his father.

[Paris, 28 December 1886]

I'm not in the process of regenerating French art at all, and I'm struggling with a hapless piece of paper that hasn't done a thing to me and on which, believe me, I'm not doing anything worthwhile.

I'd like to tell you a little bit about what I'm doing, but it's so special, so

outside, so "outside the law." Papa would of course call me an outsider—I had to make an effort, since (you know as well as I do), against my will, I'm living a Bohemian life and I can't get used to this atmosphere. The fact that I feel hemmed in by a number of sentimental considerations that I will absolutely have to forget if I want to achieve anything makes me all the more ill at ease on the hill of Montmartre....

[Letter 137]

1888–91, "Gaudeamus"

Lautrec's work began to sell, to be exhibited, and to attract much comment. With noticeable pride he kept his mother regularly informed of his progress.

[Paris, January 1888]

My dear Mama,

For two days I've been in a ghastly mood and don't know what's going to come of it. The sky is unsettled and is sprinkling us with an unconcern that proves how little feeling the Eternal Father has with regard to outdoor painters. Other than this, business is all right. I'm going to exhibit in Belgium in February and two avant-garde Belgian painters [of Les XX] who came to see me were charming and lavish with, alas, unmerited praise. Besides, I have sales in prospect though don't count your chickens before they are hatched.

I am feeling wonderfully well. And give you a kiss.

Gaudeamus.

Yours, Harry
Letter 90 from
Unpublished Correspondence of Henri de Toulouse-Lautrec,
edited by Lucien Goldschmidt and Herbert D. Schimmel, translated by Edward B. Garside, 1967

[Paris,] Monday, [9 January 1888]

My dear Mama,

...I went to the studio of Van Gogh, who told me that one of the paintings I did this summer is going to be sold this week to the director of the Goupil photoglyphy, M. [Michel] Manzi, whom I've known for a long time. On the one hand, this means I have to give him a special low price; on the other hand, it offers the advantage that my painting will be seen by a lot of people. So I'm satisfied. Gaudeamus igitur!!

Yours [*sic*] boy, Henri
[Letter 158]

A Series of Exhibition Openings

At the Salon des Indépendants, which opened on 3 September 1889...

[Paris, early September 1889]

My dear Mama,

We have been all wrapped up in the great pleasure of exhibition opening day, which was quite gay despite the pouring rain. Uncle Odon and Auntie were there and asked me when and how you were going to come....

Yours, Harry
[Letter 170]

...at the sixth Salon des Indépendants, which opened on 20 March 1890...

[Paris, 20 March 1890]

My dear Mama,

I'm still reeling from the second exhibition opening. What a day! But what a success. The Salon got a slap in the face from which it will recover perhaps, but which will give many people something to think about....

Yours, Henri
[Letter 175]

...and at the Exposition du Cercle Artistique et Littéraire, January and February 1891.

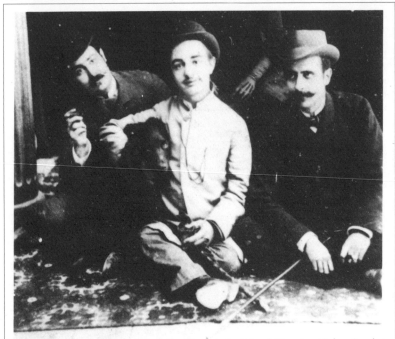

A bove: Lautrec among friends, including his cousin Louis Pascal. Opposite: *Madame Pascal at the Piano* (1895).

[Paris, January 1891]

My dear Mama,

...Yesterday I inaugurated the Volney show. My pictures are not badly positioned but they're in a light that's not as good as last year's.

I sold two studies of dancers to [Michel] Manzi, the director of the Héliogravure Goupil. Did I tell you?...

Regards, Your Henri
[Letter 185]

Good Humor Prevails

Reveling in his success, Lautrec closes his letter to his mother with lighthearted messages.

[Paris, mid March 1891]

My dear Mama,

Just now I'm very busy with the rush for the Exhibition [the seventh Salon des Indépendants], because the works must be delivered by Saturday at the latest....

Goodbye, my dear. Kiss the grannies and the other ornaments on our genealogical tree for me.

Yours, Henri
[Letter 189]

At the end of the year food exercised his mind when he sent his news home.

[Paris, December 1891]

My dear Mama,

...Has the goose-liver season started?

If it has, remember to have a dozen tins sent to me. I am re-reading my letter and find it has a gastronomic character. My poster [*Moulin Rouge: La Goulue*] is pasted today on the walls of Paris and I'm going to do another one [possibly *The Hanged Man*].

Affectionate regards to everyone around you whom it may concern. I kiss you.

Yours, Henri
[Letter 211]

1892, Roger Marx (1859–1913)

Lautrec made the acquaintance of Roger Marx, a writer and art critic who always gave him much public support.

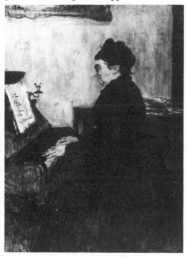

[Paris, 12 April 1892]
Dear Sir,

[Illustrator and artist Henri-Gabriel] Ibels tells me that you want to photograph one of my pictures of La Goulue. *I authorize you to take all the* PHOTOS *you want*. But no interpretation by a draughtsman, as in the magazine of unhappy memory [Lautrec is no doubt referring to his problem with Jules Roques of *Le Courrier Français*].

Faithfully,
HTLautrec
[Letter 218]

The Misfortunes of the Pascal Family

Shocked by the bankruptcy of his Pascal cousins, Lautrec tried in a series of letters to soften his mother's feelings toward them; she was more inclined to blame them than to offer help.

[Paris, June 1892]
My dear Mama,

…What you tell me about Respide was in the cards, but you know my way of looking at that situation. There's *nothing to be done* about it. Be guided by your own feelings and write to me. Unfortunately I'm too sceptical to believe in gratitude, but it mustn't be forgotten that in Respide we found what we looked for in vain elsewhere, a *home*.…

Yours, H
[Letter 228]

[Paris,] Saturday, [6 August 1892]
My dear Mama,

…The Pascals have NOTHING left. Do therefore write, whatever it costs you, and offer my Aunt *temporary* lodgings at Pérey's, as that is what seems the most practical to me.…
Write to my Aunt of your accord, because, unfortunately, the *people* we are talking to are now absolutely down and out, please don't forget it and put aside all susceptibilities, *however justified they might be*. Be charitable, *absolutely*. I kiss you.

Yours, Henri
[Letter 238]

Reporting the unfortunate situation of his cousin Louis, "with figures to back it up," Lautrec continued his exhortations to his mother.

[Taussat,] 20 [August 1892]

My dear Mama,

I've little news to tell you since yesterday and I'm writing simply to lend support to [Henri] Bourges' letter, which brought you up to date on Louis' sad situation, with figures to back it up. We'll really have to give him a hand if you don't want him to be ruined for good and lose everything that has been done up to the present. He's doing the best he can to live on the little money he has, but for all practical purposes it's impossible for him to pay off his back debts if you and my uncle (to whom Gabriel is writing on his own) don't help him out. So, for your part, send TWO HUNDRED francs and we won't ask any more for him before the MONTH OF DECEMBER....

Yours, Henri
[Letter 242]

[Paris,] Sunday, 23 [October 1892]

My dear Mama,

...More of the same old story: I laid out 70 francs for hotel rooms, carriages, etc., for my aunt. In addition, she has in storage at the railway station several chests of linens etc. rescued from the Respide shipwreck. [Gaston] Bonnefoy will keep them in one of his storage places until they can be used. *These trunks also contain clothes belonging to her and Joseph.* [Henri] Bourges is paying Joseph's share, but my aunt's share is 100 francs. This amount may seem to you excessive, but keep in mind that unless she is fitted out with a new wardrobe these chests cannot be left at the railway station, where the

storage charges are mounting up....

Now, at the risk of being considered a bore, I'm asking you one last time to come instead of behaving like an ostrich and waiting until my poor aunt gets sick, which could very definitely happen.

I kiss you.

Yours, H.
[Letter 252]

The Man from Flanders

Emile Verhaeren (1855–1916), a Belgian poet and art critic, fostered artistic contact between France and Belgium. He had noticed Lautrec at the Exposition des XX in 1891.

[Paris, October 1892]

My dear Verhaeren,

You told me to let you know when something by me appeared. An original colour print of La Goulue at the Moulin Rouge has just been published. The engraving is by me, based on my picture, or rather it's a highly transposed interpretation of the picture. To obtain it, just contact M. Joyant (c/o Messrs. Boussod and Valadon, Goupil & Co., 19 bd Montmartre). The price is one louis. The proofs are numbered from 1 to 100, the stones were obliterated in my presence.

I hope that this will be only the first in a series that I am doing and which will at least have the merit of being very limited and consequently rare.

Cordially yours, HT Lautrec
[Letter 246]

The Great Age of the Poster

[Paris,] Friday, [December 1892]

My dear Mama,

...Your natural kindness will inevitably be stirred by the good luck I've had. M. Jules Courtaut, who was in Nice with

you, talked about me to Yvette Guilbert, the singer, and yesterday in her dressing-room she asked me to make a poster for her. This is the greatest success I could have dreamed of—for she has already been depicted by the most famous people [Charles Léandre, Jules Chéret, and Ferdinand Bac] and it's a question of doing something very good. The family won't take any pleasure in my joy, but with you it's different....

Yours, Henri
[Letter 260]

More Belgian Contacts

Belgian lawyer, journalist, writer, and art critic Octave Maus (1856–1919) founded the periodical L'Art Moderne *and went on to form the group Les XX in 1883. He was responsible for the framing, publicizing, and, above all, the selling of Lautrec's work.*

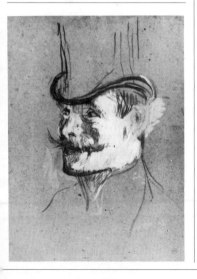

At the Moulin Rouge: Portrait of William Warrener (1892).

[Paris,] 27 January 1893

My dear Maus,

You will be receiving a package containing three prints (color litho-graphs) by me. I don't know whether I'll be able to get to Brussels for the opening of the exhibition. So I ask you please to have tabs glued on the three prints (on the top corners only) and have them placed under glass as best possible.... Send me the bill from the Exhibition framer. Then return the proofs taken from a numbered printing for which I am responsible. One (the largest) serves as a commentary for a pub-lication on which all the Young Artists are collaborating [Lautrec did a cover for *L'Estampe Originale,* published by André Marty]. Be so kind, dear friend, as to tell me who could be our correspondent in Brussels. The director is Marty, at 17 Rue de Rome, Paris. Write directly to him or to me. They'll send samples and rates. I think that won't be bad. For the other prints (*La Goulue* and *L'Anglais au Moulin Rouge [The Englishman at the Moulin Rouge]*), the Maison Goupil at 19 bd Montmartre should be contacted. This is the only depository of my original prints. The price is 20 francs. My picture of La Goulue is for sale at 600 francs and the other (*Au Lit [In Bed]*) at 400 francs. When are Les XX opening? Write or telegraph. I'll try to be there and forgive me for all the bother.

Yours, HTLautrec
[Letter 270]

Through Roger Marx, a native of Lorraine, Lautrec met René Wiener, a bookbinder from Nancy. Lautrec produced drawings for two of the latter's bindings: Impressionist Art *and* Goya's Tauromachy. *Lautrec's letters testify to his rigorous technical standards.*

[Paris, March–May 1893]

Dear Sir,

Here are two tracings, one of the line, which I ask that you follow *religiously*, keeping the whole thing *very vigorous*, especially the head and the *beak*. As for the ship, the photograph will give you the information. The bird's body is *dark green* with the hood feathers being lighter—the collar and the cheek are an orange-yellow—the eye is malachite green, the sky is dark ultramarine and the patch of water *on the right* is a *lighter ultramarine*, the water is *emerald* green; as for the boat and the sand keep the background leather.

The inside of the beak is a *yellow grey*, lighter than the background of the leather and the throat is a *slightly creamy* white.

I hope, Sir, that in this way you will be successful and I would like to know the outcome.

Regards, H. de Toulouse Lautrec
[Letter 290]

The Yvette Guilbert Album

[Paris,] Sunday,
[10 December 1893]

My dear Marty,

When you come to *La Justice* [a liberal newspaper for which Geffroy wrote on a regular basis] tomorrow MONDAY please bring with you some samples of your printer's type so that Geffroy can make a choice. He strongly recommended it.

Yours, HTLautrec
[Letter 327]

An 1893 sketch of Yvette Guilbert.

[Paris,] Friday, [December 1893]
My dear Geffroy,

Marty is delighted to have your Yvette Guilbert plan executed. Prepare the plaquette when you can. I'll do the same for the drawings. Now, what do you want to entitle it. *Please drop me a line* about this for the announcement just plain "Yvette" wouldn't be bad.

According to Yvette, a little bit too Belgian. Take a look and let me have your answer.

Regards, HTLautrec…
[Letter 328]

The Price of Butter

[Paris,] Friday, 29 December [1893]
My dear Grandma [paternal],

…You will be seeing, or have seen, the celebrated Doctor Gabriel, who will have told you about our numerous labours, he bloodthirsty, I a printer. He may have told you, perhaps, that since my friend [Henri] Bourges is getting married I'm forced to change my apartment, which is not very amusing. But I have found very suitable quarters in the same house where my studio is [at 7 Rue Tourlaque, where he moved in January 1894]. I shall have the ineffable pleasure of keeping my own household accounts and knowing the exact (?) price of butter. It's charming.

Please remember me to all and I kiss you, and count on me to see you soon. Happy New Year.

Your respectful grandson,
H de Toulouse Lautrec
[Letter 332]

1894–6, Involvement with the Theater

Amsterdam, Thursday
[15 February 1894]
My dear Mama,

For three days we've been in the midst of Dutchmen who hardly understand a word you say. Fortunately the little English I know and *pantomime* get us along.… The amount of beer we're drinking is incalculable, and no less incalculable the kindness of Anquetin, whom I cramp with my small, slow person by keeping him from walking at his own pace, but who makes believe it doesn't bother him.

And soon all the details. Saturday or Sunday.

Yours, Harry
[Letter 343]

In late 1894 Lautrec designed the set and program for the play Le Chariot de Terre Cuite (Earthenware Chariot), *an adaptation of a classic Hindu piece at the Théâtre de l'Oeuvre.*

[Paris, late 1894]
My dear Mama,

I beg your pardon for having been such a poor scribbler, but I'm up to my ears in work and a little fagged out meanwhile. Nothing but marches, counter-marches, appointments, etc., etc. I have even made my debut in a new line, that of stage-designer. I have to do the stage scenery for a play translated from the Hindustani called *Le Chariot de Terre Cuite*. It's very interesting, but not easy. Besides, no use counting one's chickens before they're hatched.…

Yours, HTL
[Letter 396]

"The Simpson's Lever Chain"

Lautrec produced drawings of the bicyclists racing at the Vélodrome Buffalo and took them to London for a meeting organized by Louis Bouglé (alias "Spoke"), sales manager of a company that made the Simpson bicycle chain.

Paris, Friday, [May–June 1896]
My dear Mama,

I thought I'd told you I'd be back from London in two days. I stayed there from Thursday to Monday. I was with a team of bicyclists who've gone to defend the flag on the other side of the Channel. I spent 3 days outdoors and have come back here to make a poster advertising *The Simpson's Lever Chain,* which may be destined to be a sensational success....

Yours, Henri
[Letter 462]

1897, *Au Pied du Sinaï*

In one of his pithy missives to his mother Lautrec wrote of the heat, his moves, recent doings, and inevitable money problems.

[Paris, May 1897]
My dear Mama,

...My friend Joyant has definitely bought the Goupil gallery. I'm finishing a book with [Georges] Clemenceau on the Jews [*At the Foot of Sinai*]. My publisher owes me 1,200 francs. He'll give me 300 of it tomorrow. Let me know if you can advance me 500 francs on the 900 balance. Repayable in six months. If you can't, I'll make other arrangements. I hope to place my maid in a good house. I'm sweating like a bull and kiss you.

Your Boy, Henri
Forgive all the figures, but business is business....

[Letter 480]

"Will I Become a Stay-at-home?"

In 1898 Lautrec began experimenting with etching. There were numerous letters about an English version of Yvette Guilbert's album. He did not write very frequently to his mother.

[Paris, early 1898]
I haven't written to you sooner because I'm in a rare state of lethargy. I'm relishing my avenue Frochot quiet so

Aₙ 1896 lithograph entitled *Cycle Michael.*

much that the least effort is impossible for me. My painting itself is suffering, in spite of the works I must get done, and in a hurry.... There you are, my dear Mama, a very quiet accounting. Will I become a stay-at-home? Anything can happen and I have only one trip to London in April to make me budge.

On that I kiss you.

Yours, Henri
[Letter 493]

Lautrec may already have been in the grip of alcohol and mentally confused. In 1899 he was put under restraint.

A Call for Help

From the sanatorium in Neuilly, Henri sent a moving appeal to his father....

Papa,

This is your chance to do the decent thing. I am confined, and all confined things die.

...and to his faithful friend Maurice Joyant.

[16 Avenue de] Madrid,
[at Dr. Sémelaigne's sanatorium in Paris]
17 March 1899

Dear Sir,

Thank you for your kind letter. Come to see me. Bis repetita placent. [It's worth repeating.]

Yours, T. L.

Send me some grained stones and a box of watercolours with sepia, brushes, litho crayons, and good-quality India ink and paper....

[Letter 564]

Berthe Sarrazin

Trusting his housekeeper, Berthe Sarrazin, whom his mother had sent to Paris to look after her apartment in Paris and her son, he secretly sent her some requests.

16 Avenue de Madrid, Neuilly
[12 or 13 April 1899]

Dear Madam,

I beg you to come to 16 Avenue de Madrid *in the morning* and bring a pound of good *ground coffee*. Also bring me a bottle of rum. Bring me the whole lot in a locked valise, and ask to speak to me.

Very truly yours,
H. de Toulouse Lautrec

Bring me all the mail. Newspapers, printed matter, etc.

[Letter 567]

Berthe Sarrazin sent a daily report on Lautrec's health to his mother, Adèle. Her letters, full of concern, speak of her boundless devotion.

Paris, 4 January 1899

Madame la Comtesse,

When I got back in the evening yesterday I went to Monsieur Henri's. He was getting himself ready to come to dinner. I told him that Madame had left. He was very angry. He swore and pounded the floor with his cane. He took a carriage. He came to the house, he rang the bell so hard he almost broke it. The concièrge told him there wasn't anyone there....

He made me look for the keys to the apartment. He thinks he has lost them. He's getting back his memory a little. I think that in a few days the trouble will have disappeared. He told me he didn't understand what kind of fast one they were pulling on him, why Madame hadn't warned him, that when there was something happening in the family he was always told first....

I will do my best to justify Madame's confidence and will do the best I can to take care of Monsieur Henri.…

Berthe Sarrazin
Letter 238 from
Unpublished Correspondence of Henri de Toulouse-Lautrec,
edited by Lucien Goldschmidt and
Herbert D. Schimmel, translated by
Edward B. Garside, 1967

Paris, 10 January [1899]
Madame la Comtesse,

I wish I could give Madame better news, but unfortunately it's the same story. However, Monsieur is calmer at the moment. He talks very sensibly at times but you mustn't go against him. For example, yesterday at lunch he wanted to put rum into the dish of orange preserves. I wanted to stop him and he put me in my place in no uncertain terms. He said he was the master. You always have to approve, to say yes all the time, otherwise he's not bad. All he talks about is giving presents to everybody.…

At 11:30 [Edmond] (Calmèse) [the owner of a livery stable who encouraged Lautrec in his drinking habits] had his stable-boy come to get Monsieur. I think they were to have lunch together. I'm going to go back a little later. I am staying as long as possible at his place. He talks and talks and he doesn't go out. He forgets to drink. If one could be with him all the time to keep him busy perhaps he wouldn't think about drinking any more.…

Letter 244 from
Unpublished Correspondence of Henri de Toulouse-Lautrec,
edited by Lucien Goldschmidt and
Herbert D. Schimmel, translated by
Edward B. Garside, 1967

Paris, 15 January 1899
Madame la Comtesse,

Monsieur hasn't paid his rent. When the concièrge presented him the bills he said that he was not on good terms with his family, that a week from now it would be taken care of.…

Berthe Sarrazin
Letter 250 from
Unpublished Correspondence of Henri de Toulouse-Lautrec,
edited by Lucien Goldschmidt and
Herbert D. Schimmel, translated by
Edward B. Garside, 1967

Paris, 16 January 1899
Madame la Comtesse,

…Monsieur is somewhat better but is very much put out because of the money. He told me this morning that Calmèse had found him moneylenders at thirty per cent. There's a danger they'll get him to do something really foolish. I've just come from his place. There were 2 men there I didn't know. He sent me away.… He promises wine to everybody, to Big Gabrielle [a prostitute], to the stable-boy. He says that it's his. I haven't given anything to anybody yet. Fortunately he forgets about it.

Now he doesn't want to see [his cousin] Monsieur Gabriel any more. He told me that if he came I should throw him out, that he was a spy.…

Berthe Sarrazin
Letter 251 from
Unpublished Correspondence of Henri de Toulouse-Lautrec, edited by Lucien Goldschmidt and Herbert Schimmel, translated by Edward B. Garside, 1967

Bordeaux, Operas, and Sales of Work

Lautrec's last letters were to his mother, grandmother, and Maurice Joyant, to whom he reported on his frenetic activity.

[Bordeaux, 6 December 1900]

Dear Sir,

I am working very hard. You will soon have some shipments. To which address should they be sent…? Orders.

I am taking advantage of the situation in asking you for two or three copies of the play of [Zola's] *L'Assommoir*. Send everything to Rue de Caudéran, Bordeaux. *La Belle Hélène* is charming us here, it is admirably staged; I have already caught the thing. Hélène is played by a fat t[art] named Cocyte.…

Yours, T. L.

[Letter 598]

[Bordeaux, mid December 1900]

My dear Maurice,

Do you have photographs, good or bad, concerning [Isidore] de Lara's [opera] *Messaline*. I am fascinated by this opera, but the more documentation I have the better it will be. The press said very kind things about my daubings. I hug you.

Yours, T. L.

[Letter 601]

Lautrec's last letter to Joyant, dated 4 June 1901, is a receipt, for the sum of three thousand francs, for the sale of Jane Avril Leaving the Moulin Rouge.

The Singular Henri de Toulouse-Lautrec

Lautrec was physically malformed and given to drunkenness: These were the only points on which his friends and enemies were agreed. The former felt affection and admiration for him, the latter suspicion and unease.

Lautrec in an Eastern setting.

The American Bar on the Rue Royale

François Gauzi, an artist from Toulouse, was a pupil at the Cormon studio with Lautrec. He left his substantial collection of the latter's work to the Musée des Augustins in Toulouse.

I had got in the habit of seeing Lautrec only by arrangement. I did not know whether he was again having difficulties with his visitors or whether he had grown tired of being barman when he said, "I have definitely given up for today. If you want to see me, you'll find me at the American bar on the Rue Royale—I'm always there at drinks time."

I went to see him at the bar. He was seated on a high stool against the bar, playing "zanzi," in other words, dice, with friends. Catching sight of me, he took his leave and we went and sat at a table outside.

"What will you have?"

"Whatever you like, whatever you're having yourself." He ordered two ports. At the urging of his mother and Dr. Bourges he was on a cure trying to avoid spirits; he was sticking to wine.

Wherever he found himself, Lautrec kept a lookout for characters, and he had found a real specimen at the bar. "You see that big man at the counter? The one with a top hat and an elegant flower in his button hole? That's Tom, the Rothschilds' coachman—isn't he terrific?" He was, in fact, one of the regular clients of the bar, and Lautrec often drew him in 1896.

When he moved his studio from Rue Caulaincourt to Avenue Frochot in May 1897, he said, "I'm never in, and if

I am, I never answer. Anyway, old man, come and have a look at my roost!" It was like being in a storage-room for canvases. Everything was orderly, with the canvases neatly lined against the wall, and no painting in progress on the easel: I was in a desert.

François Gauzi
Lautrec et Son Temps, 1954

At the Ecole des Beaux-Arts

Seated, he looked almost like the other boys, holding his head upright, though it must have weighed on him—a head permanently on the alert, a boy meticulously dressed and always in black or dark blue, even in summer. His cheeks were shining with cleanliness and color. His hair, which he had carefully combed, was no less shiny. The hairs that had begun to curl on his chin were of the same striking black. But what shone most of all was, behind his glasses, a pair of piercing coal-black eyes, eyes eager to see everything, practiced at observation, and two protruding wet lips. From the moment of his arrival, he responded to everything. Until the moment of his departure, he excelled over all the rest.

Thadée Natanson
Un Henri de Toulouse-Lautrec, 1951

Lautrec's Appearance

Henri de Toulouse-Lautrec was very small, very dark. He looked like a dwarf, the more so because his torso, which was that of a man, seemed, on account of its weight and that of his large head, to have crushed what little in the way of legs forked below. His hands and his head, which was at least to scale with his torso, looked all the more out of proportion because of the way that this head nodded, unstable as any heavy hanging thing, and that between the inkiness of his beard and the Indian inkiness of his hair—vigorously smoothed with brushes and glistening with oil— protruded an enormous mouth, swollen with blood, over which the commas of his moustache seemed to drip. His hand, with its huge fingers, strong enough to hold a large palette and all its brushes, also handled curios with delicacy, and the little stick of wood with a curved head that he referred to as his cane—a child's cane, which nonetheless helped him to walk, to get about. When he was amenable. He was always in some conveyance and often badgered one or other of his friends to go around the Salon with him, side by side, in a wheelchair. Contrivances and jokes were his way of concealing the terrible effort of walking. Those who had seen him naked retained a lasting impression of his virility, realizing how much he deserved the name "penis on legs." But as nothing, in his eyes, was ever extraordinary enough, he would readily disguise himself further with the ferocious grimaces that he knew to be the speciality of actors in Japan.

We who adored him, whom he tyrannized, no longer recognized the portraits put before us, no longer heard him snort, nor the merest suggestion of an accent distorting his words. We saw only his small misshapen figure, eyes shining with wisdom and tenderness, crossed now and then with a flash of anger: The lenses in his lorgnette intensified their brilliance.

Thadée Natanson
Un Henri de Toulouse-Lautrec, 1951

At the Cycling Track

The founder of La Revue Blanche, *Paul Leclercq, left a fascinating recollection of*

Lautrec, describing his distinctive, indeed inimitable, figure.

In his early Paris days Lautrec was often to be seen at the race course, on the bicycle tracks that were then popular, in the music halls, at the circus, and in all open-air places.

He loved sport, and nothing was of greater interest to this little misshapen man than the sight, in a sunny paddock, of a thoroughbred with a supple and nonchalant gait or, on a bicycle track, of a racer with powerful and elegant muscles.

Tristan Bernard was at the time director of the Vélodrome Buffalo, and there he could be seen every evening, very busy, hat thrust back on his head, pistol in hand, starting the various races amidst a throng of journalists and time-keepers.

Lautrec, as a good friend, had free access to every nook and cranny of the Vélodrome.

He spent his mornings there, happily venturing into every corner, into the middle of the track, and into the racers' quarters.

His diminutive form crossed paths with huge athletes whose strength and brutish heads he admired. The tiniest detail of their attire amused him.

A short distance behind followed an elongated figure, nose to the fore, stooped and round-shouldered. Now and then Lautrec turned to him and, lifting his finger to point out some muscular brute whose size impressed him, he murmured: "He's tremendous!"

His thin cousin nodded in silent agreement. On these morning outings he sported a putty-colored overcoat the length of a jacket, and a pair of skin gloves, pink as bare hands....

Though Lautrec's handicap prevented him from taking exercise, he was very much drawn to sport. And he assured me on several occasions that if he had been made like everyone else, he would have hunted rather than painted.

Paul Leclercq
Autour de Toulouse-Lautrec, 1954

At the Moulin Rouge

Writer and critic Gustave Coquiot is known for his works on the history of art, in particular those on Van Gogh and Seurat. He wrote about Lautrec as both a critic and a friend.

I was bowled over by Lautrec's work when I went into the Moulin Rouge one evening, a long time ago. Two of his extraordinary paintings were, as far as I remember, exhibited on the stairs; and never in my life will I forget that *Cirque Fernando* and *The Dance,* which struck me as utterly new and strange....

As I was looking at them, someone mentioned the name Henri de Toulouse-Lautrec.

That instant, in a rush of imagination, I said to myself, I swear that the artist must be physically different than other men. Yes, to my mind his paintings truly spoke of a bizarre being, in an altogether different category than the prevalent image of the artist. Was he an acrobat who painted in his spare time? A clown or a rider? The novelty of the situation set me pondering. And my thoughts quickly took root. So much so that when, another evening, I saw the paintings again, I could not envisage the artist as anything other than disturbing and abnormal....

Ah! We were far removed from the placid females imagined by other

painters of the Female, by Constantin Guys, for example, later supposed to have influenced Lautrec, such was the proliferation of nonsensical theories.

In any case, I found it hard to tear myself away from these sharply cut faces, from the broad brush strokes of the twisted chignons. Above all the eyes, those watchful eyes, beneath eyelids like shutters! And those sheer profiles, those heavy throats! Ah! What a zoo, I could sense the heady smell of it!… I admired them again…and then a friend took me by the arm and led me to the dance.

Gustave Coquiot
Henri de Toulouse-Lautrec, 1913

In the Sea

He spent the months of July and August, and sometimes all of September, at Arcachon. He adored swimming and spent his afternoons in the water, giving up alcohol for fear of drowning, with remarkable benefit to his health….

He could be seen coming down from the Villa Denise barefoot, his red wool trousers pulled up to his knees, and over them a tight blue jersey. A hat on his head; generally a naval officer's cap, but always without braid.

His other passion, at Taussat, was to train cormorants. He was often accompanied by one of these creatures; the pair of them would waddle around the beach; and Lautrec did not find his companion any more absurd than the lobster that followed Gérard de Nerval.

He livened up his summer holidays with fancy dress, organizing Oriental parties; and, having climbed to the highest window of the villa, he would call the faithful to prayer like a muezzin.

Gustave Coquiot
Henri de Toulouse-Lautrec, 1913

In the Brothel

For some time Lautrec had been making forays out of Montmartre, disappearing for days at a time; his close friends were soon given the key to the mystery: A number of the brothels on the Rue des Moulins, the Rue d'Amboise, and the Rue Joubert had become his working headquarters.

There he saw the nude, the nude in motion, rather than the typical studio nude in conventional pose who says: "I've sat for Bouguereau and for M. Cabanel. I do not model my whole body, but only my head for M. Henner."

Lautrec taking a nap.

Lautrec had his fill of professional models; he wanted subjects that were closer to nature, whose gestures and attitudes were almost wholly uninhibited. He sought an animal freedom of movement. And in the brothels, where some of his doctor friends justified their presence by examining the nerves and hearts of the inmates, many of them fit cases for the Salpêtrière [asylum], Lautrec tirelessly painted and drew, observing the life of these recluses in minute detail.

Maurice Joyant
Henri de Toulouse-Lautrec, 1927

In the News

When Lautrec was put in a sanatorium, controversy broke out in the press.

Toulouse-Lautrec's friends will say that they are not surprised, the outcome was inevitable, Toulouse-Lautrec was destined for the sanatorium. He was confined yesterday, and now madness, unmasked, is officially recognized as the creator of his paintings, his drawings, his posters, where it has lain concealed for so long.…

But it was above all in his perception of reality that this apprentice madman revealed himself. Toulouse-Lautrec's conversations seemed to emanate from a demolition contractor. His talent judged that nobody had talent, his heart that nobody had a heart.
The world consisted only of cretins, wretches, bastards: All the men are fit for lunatic asylums—Sainte-Anne, Mazas, the Aquarium; as for the women, things are simpler still—they belong in the meadows where the cows are grazing.

Alexandre Hepp
Le Journal, 26 March 1899

"He is to be envied"

There was a chorus of sympathy today, without a note of dissent, for the painter Toulouse-Lautrec, who has recently been taken to a sanatorium.

This sudden plunge into the darkness, this slide into the abyss, is always distressing. In artistic, literary, and social circles the extinction of the artist's flame disturbs us like a warning, generates fear like a threat. Normally little affected by the illnesses and accidents that befall our friends, we are perturbed by the terrible question mark that hangs over madness.…

We are wrong to feel sorry for him, he is to be envied. It is the madmen,

Lautrec as depicted by Charles Maurin.

and not the beggars, as Béranger foolishly wrote in his song, who are happy; the human condition is so

peculiar, so horribly hateful, so cruelly storm-tossed between impotent desire and incomplete satisfaction, that the only place on earth where one can hope to find happiness is in a padded cell in a lunatic asylum. Ah! The fortunate Toulouse-Lautrec! It is fair to say that he has suffered enough to experience healing, and he fully deserves it, after the ordeals of partial madness, when he struggled like most men to attain the divine oblivion of total madness at last.

Emile Lepelletier
L'Echo de Paris, 28 March 1899

"It is too sad!"

What scant trouble people can take at times in Paris to learn the truth, when the means of discovery are so close at hand! What little effort is made to divine the faces behind the masks! This city is sublime, abounding in great talent, in profound and serious minds, and sometimes behaving disconcertingly like a bear garden....

The things that have been written about Lautrec are stupefying. They show that none of those who devote entire columns to him has ever met him. According to these articles, though the poor boy could be doomed, diagnosed as dying by doctors, the victim of total paralysis, he has never been better. He could be mad, have lost his memory, the use of his eyes, which looked on the world with such penetration and humor, of his hands, which wielded the pencil to such exquisite and trenchant effect; he continues to draw marvelously and is in excellent form. He is said to be a pitiful wreck, miserably unbalanced; and he is a remarkable artist. A bohemian chasing after a 100-sou coin; and he has enough money to work as it

suits him. He is said to have produced little, having an aversion for any serious task; he has drawn for fifteen years with real passion, real fervor and produced a great oeuvre. Otherwise everything that has been written about him is almost true....

Now here is what I saw.

In a place near Paris, let's say Vincennes, Saint-Cloud or somewhere else, I went into a house by the Seine, close to woods. An utterly adorable house, built under Louis XVI for some all-powerful and rich official who spared no expense....

But it was a place of suffering. Taken there by a trick and forcibly detoxified, he has been restored to health and lucidity. But what when he leaves, tomorrow, or in two weeks, or in three months? When wafts of gin, beer, absinthe, and rum again cross his nostrils, like unhealthy vapors rising from the pavements of Paris, at certain times and in certain streets?... When the bevies of unconcerned revelers, of fine parasitical youths, of weird and suspicious drifters, once again fall upon their quarry and plaything, with all the more curiosity because he is come from farther away, when his friends are again rendered virtually powerless to protect him from himself, what will become of him?...

All the same, I am reassured, and I reassure. It is too sad! Now if anyone chides me for speaking very seriously of a man who has provided amusement to many who do not understand him, I shall answer that it is from a delight in justice, which knows no pleasure equal to mocking individuals who are taken too seriously, with less reason.

Arsène Alexandre
Le Figaro, 30 March 1899

Obituaries: A Selection

"Just as there are people who love watching bullfights, public executions, and other gruesome spectacles, there are people who love Toulouse-Lautrec." Jules Roques' statement sets a tone. Maurice Joyant's is more lighthearted: "Lautrec amused himself in life with the utter freedom of a little boy in a park."

"Fortunately for Mankind There Are Few Artists of His Genre"

A draftsman, M. de Toulouse-Lautrec, last representative of one of the oldest and noblest families in France, has apparently just died at the age of thirty-seven [he was, in fact, two months short of turning thirty-seven], in an asylum where he had had to be confined several times.

He was physically one of nature's most unfortunate specimens, a type of Quasimodo at whom one could not look without laughing. Was it because of this that he had such an aversion to humankind and dedicated himself, for some years of his artistic life, to deforming, caricaturing, and vilifying all his models? As he could not hope to inspire any emotion, he took his revenge on love, laboring to render ridiculous, base, sordid, or vulgarly obscene the ladies of Montmartre, whom others would have viewed with more humanity and even with a degree of compassion and a touch of poetry.

While clearly a man of property and very well-off, Toulouse-Lautrec adopted the airs of a Montmartre bohemian.

Thanks to his financial situation and family connections, he was able to publish most of his lithographs and art critics "took an interest" in him.

Important newspapers compared him very seriously to Goya. This was his undoing. Artists acclaimed in their lifetime pass into oblivion quickly. Toulouse-Lautrec went mad. He was confined. Once restored to liberty, he went out only under escort. The last time I saw him, a month ago, was

Lautrec in around 1892.

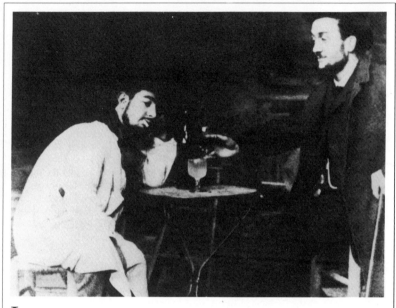

Lautrec and Lucien Métivet at Le Mirliton (above).

at the Pavillon d'Armenonville, at lunchtime, watching the procession of fashionably dressed ladies with a dazed and absent air.

Toulouse-Lautrec was introduced to me a few years ago and it was in *Le Courrier Français,* I believe, that his first drawings were published—the originals fetched no more than six francs at the time in the Hôtel Drouot. Advertising had not yet made him famous. By nature he was full of hatred, insensible to all noble forms of expression.

Very up-to-date on the civil and commercial Code, he, the rich artist, would never give a centime's benefit of the doubt to the wretched dealers who handled his works. Accountant and bailiff in one, he was adept at setting in motion the wheels of justice and issuing streams of official notices the instant he thought his interests were at stake, even for minute amounts.

"Would you not like to behave generously for once?" he was asked.

"I would like to but I can't," he replied, "it is in spite of myself."

Just as there are people who love watching bullfights, public executions, and other gruesome spectacles, there are people who love Toulouse-Lautrec. Fortunately for mankind there are few artists of his genre. Toulouse-Lautrec's talent, for it would be absurd to deny him talent, was bad talent, pernicious in its influence and depressing.

Jules Roques
Le Courrier Français
15 September 1901

"Lautrec's Pencil Scourges"

Like the caricaturist André Gill, the caricaturist H. de Toulouse-Lautrec has just died, in an asylum, after terrible crises, after a fierce and vigorous struggle for his health, for his life.

Toulouse-Lautrec had been confined before, three years previously, but had managed to leave the ghastly madhouse and resume his normal way of life; he reappeared in Paris at the time, parading his ravaged face and uttering incoherent phrases; from that point, he was a marked man.… Shortly after, he was forced to return to the terrible establishment in which he has just died.

The last representative of one of the oldest and noblest families in France, of the Comtes de Toulouse who had the ancient right to marry the daughters of their kings, the descendant of one of the most distinguished leaders of the first Crusade, Toulouse-Lautrec was short, fat; he looked like a monstrous gnome, with his short stature, his heavy head and his eyes popping out of their sockets.… Bandy-legged, to boot, Toulouse-Lautrec was a lamentable sight, one of nature's most unfortunate specimens; he was Quasimodo.

In Montmartre there was no café waiter, no head waiter, no woman unacquainted with this deformed dwarf, whose generosity was proverbial. In the taverns, in the late-night restaurants, this man, who looked like a court fool, spent his days studying vice, entertainment, dissipation, orgies in Paris. And his studies have brought us *The Hanged Man, Reine de Joie, Babylone d'Allemagne, La Goulue Entering the Moulin Rouge,* and a hundred works depicting grotesque vice, degenerate entertainments, and lewd dissipation.…

Lautrec could not be better assessed; his talent is made of bitter perversity and terrible joy. Lautrec's pencil scourges, Lautrec's pencil brands, rendering servitude, rendering death.… But in electing to live in these insalubrious circles, sickly and frail as he was, Toulouse-Lautrec was possessed by the madness of his figures, the madness of his heroes; seeing madmen constantly circulating round him, he himself went mad.… His work wore him out, his work killed him.… Lautrec left forty canvases, at the most, forty canvases featuring Montmartre scenes, he left very curious posters, notably an extraordinary Bruant; he left hundreds more lithographs and studies for pictures never realized.

Among all the painters of our age, Lautrec will undoubtedly leave his mark, the mark of his curious talent, his bad talent, the talent of a deformed being, who sees all the ugliness around him and exaggerates the ugliness of life, pointing out all the defects, all the perversities, all the realities.…

Emile Lepelletier
L'Echo de Paris, 10 September 1901

"A Certain Celebrity in an Ugly Genre"

We have just—a few days ago—lost an artist who gained a certain celebrity in an ugly genre. I am referring to the draftsman Toulouse-Lautrec, a bizarre and misshapen character whose view of the world was shaped by the limitations of his own physiology. Toulouse-Lautrec, who claimed to descend from the Comtes de Toulouse, devoted himself to grotesque and somewhat obscene caricature.

He found his models in low places of entertainment, brothels, dance halls,

wherever depravity deformed people's faces, coarsened their features, and exposed the ugliness of their souls in their expressions. His favorite types were the pimp, the girl of easy virtue, the pallid layabout and the alcoholic. As a result of frequenting this fine world and wallowing in its misery, Toulouse-Lautrec himself succumbed to infection.

He died wretchedly, ruined in mind and body, in a lunatic asylum, having suffered a terrible attack of madness. A sad end to a sad life!

Jumelles
Lyon Républicain, 15 September 1901

An "Independence of Mind"

Tristan Bernard knew Lautrec when he was at the height of his talent and in full possession of his faculties.

What a remarkable individual was this big little man! When he left this life, so young in age, someone said that it was not a death, and that the strange Lautrec had simply returned to the world of the supernatural....

Now we realize that Lautrec strikes us as supernatural only because he was natural in the extreme. He was a truly free spirit. And, in his independence of mind, lacked all rooted prejudice.

He did not despise established ideas: He refused to submit to any form of authority.... So unsystematic was his avoidance of them that he would happily adopt one on occasion if it seemed to him valid. The opinions of this real original were perfectly liable to coincide with those of the world: While freely following his own path in life, he sometimes

found himself unexpectedly on the public promenade, brought there neither by social custom nor the concert hour.

Lautrec amused himself in life with the utter freedom of a little boy in a park. I assure you, this little man was master of his fate and lived by his own lights.

Tristan Bernard quoted in Maurice Joyant, *Henri de Toulouse-Lautrec 1864–1901*, vol. II, 1926–7

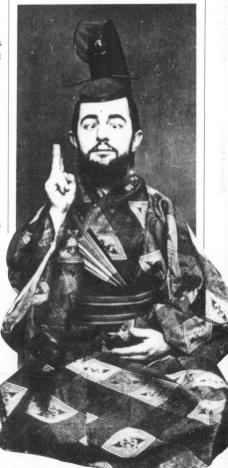

Lautrec in around 1892 dressed as a samurai.

The Musée Toulouse-Lautrec

The Musée Toulouse-Lautrec, inaugurated on 30 July 1922 in Albi, occupies the splendid Palais de la Berbie which, after the separation of the French church and state in 1905, had become the property of the French department of Tarn.

The Musée Toulouse-Lautrec at Albi.

The museum in Albi would never have come into being without the dedicated efforts of Maurice Joyant, who refused to give up when, in 1901, the Musée du Luxembourg in Paris turned down his offer of a collection of lithographs and paintings from Lautrec's studio. The curator Léonce Bénédite and, above all, the under-secretaries of state for the fine arts, Dujardin-Beaumetz and Léon Bonnat, firmly refused to let his work join the national collections. In 1905 Joyant suffered a further setback: the Portrait of M. Delaporte *was rejected by the Trustees of the National Museums of France, although it had been recommended by the Comité Consultatif des Conservateurs.*

It was not until the exhibition of December 1907 at Toulouse that Lautrec's talent began to be recognized in his native region. Gabriel Tapié de Céleyran then suggested to Joyant that a Toulouse-Lautrec section be created at the museum in Albi. The two men managed to persuade Edouard Andrieu, the senator-

mayor, to agree. After the war the project was finally realized, resulting in one of the finest museums in provincial France and bringing together nearly 600 works by Lautrec, including a unique collection of 215 paintings.

It was to Maurice Joyant that Lautrec's father, on 22 October 1901, addressed a remarkable letter that made Joyant a sort of executor and a legatee of his son's work.

Maurice Joyant.

Letter from Count Alphonse de Toulouse-Lautrec to Maurice Joyant

I'm not making a generous gesture in giving you all my paternal rights, if there are any as heir of whatever our deceased produced; your brotherly friendship had so quietly replaced my weak influence that I am being logical in continuing this charitable role for you if you so desire, simply for the satisfaction of your kind-heartedness toward your classmate; so I have no plans to change my opinion and, now that he is dead, praise to the skies something

that during his life I could regard only as audacious, daring studio studies.

The Letters of Henri de Toulouse-Lautrec edited by Herbert D. Schimmel, 1991

The collection of Lautrec's paintings, drawings, and posters—mainly stock from his studio given to the town of Albi by his mother—enriched a small provincial museum that had once been devoted to regional archaeology. Joyant, Tapié de Céleyran, and other friends and relations of Lautrec, added to his mother's gift.

The Inauguration of the Musée Toulouse-Lautrec

Lautrec's subject, constantly renewed, was portraiture, landscape featuring merely in an accessory capacity. He did not of course wish to paint only grand ladies, duchesses, famous artists – and an irreparable misunderstanding arose here from the start, born on the one side of fear of not being sufficiently flattered, on the other of apprehension in a man who was afraid of being viewed as a curiosity. The painter thus returned to his easier contacts with the popular world. He would do a portrait when, after spending some months on a subject, the model he had quietly been observing pleased him—and he had no thought of money. This does not mean that portraits were one of the main bases of his work, which developed in his renderings of the bustling, hectic life he observed between 1882 and 1901, in hospitals, at the races, on bicycle tracks, at circuses, *café-concerts,* music halls, places where the nude moved freely— and not the nude of the conventional studio. In this way he came to produce the vast number of nearly four hundred original lithographs, famous posters,

several thousand sketches, very numerous paintings, an impressive collection of which you have here.

Gentlemen of the town of Albi, we entrust to your care, in perpetuity, the work of the painter Henri de Toulouse-Lautrec, which will become an object of pilgrimage to all art lovers.

Excerpt from the speech made by
Maurice Joyant,
30 July 1922

The collection initially suffered from lack of space, but it was reorganized in 1934, and a modern art gallery was added later, underlining Lautrec's contemporaneity. The following is a portion of a speech given on that occasion by Léon Bérard, France's Minister of Education and the Fine Arts

Ladies and gentlemen,

The ironists of public life sometimes dispute the usefulness of ministerial visits. I have to agree that they are not all absolutely necessary. The one which brings me here today is by way of making amends....

Nine years ago, at the opening of the new rooms of Ingres' drawings at the Musée de Montauban, the Under-Secretary of State for the Fine Arts, extolling the great classic painter, ventured to mention his admiration of the "odalisques" of Toulouse-Lautrec.

This association of the two men, if made on geographical grounds alone,

shocked no one in the rich and illustrious shrine of academic tradition. The rivalries and disputes between schools that form so essential a part of artistic life often keep artists from being fairly judged in their lifetime. Moreover, when it comes to painting, the full merit of a work can apparently be appreciated only after the passage of time....

The Under-Secretary of State in 1913 openly congratulated himself in your presence on being given the opportunity by the kind and hospitable invitation of the municipality of Albi to acclaim Toulouse-Lautrec in his native town, after having praised, at Montauban, his illustrious predecessor and his imperial neighbor.

When a man whose greatness lay in his mental gifts has suffered from his legend and the misfortunes of fate, the tribute paid him is in the nature of an

A t the Café
de Bordeaux
(1900).

atonement. There, in the most general terms, is the meaning of this artistic occasion. We thank those who, with laudable generosity and excellent taste, have helped to organize it: the Toulouse-Lautrec family, which is too good a judge of true nobility to be unaware that no one has failed to contribute to their native region an original, forceful, honest work of art; the painter's model friend, M. Joyant, who in homage to his friend has surrendered his most precious souvenirs and most beloved treasures; the town of Albi, the staff and curator of the museum, who have arranged his drawings and paintings to establish, between Toulouse, Montauban, and Castres, a place of pilgrimage which admirers visit in increasing numbers to see the plastic genius of the Midi revealed....

Would our painter not have done better, where his own reputation is concerned, to have contemplated the azure skies and healthy country women instead of studying, too often in an atmosphere laden with the fumes of alcohol and tobacco, the grim representatives of fallen humanity? My answer is that Lautrec, who died at the age of thirty-eight [Lautrec was, in fact, thirty-six], left an oeuvre sufficiently various to show that no misfortune would have limited his talent or chained his pencil to a narrow range of lifestyles and characters. Above all, my answer is that if an artist sets out to portray his contemporaries, he is as interested to observe them in their pleasures as in their virtues: He essentially tries to study them when they are not overly concentrated on maintaining a pose.

Lautrec excelled at perceiving and rendering the predominant character of a face, the particular flavor of a social world or group. And he applied himself to portraying with a sort of bitter loftiness the wretched absurdity of men seen in their amusements. Would one have wanted him, on the pretext of raising the tone or extending his range, to renounce the essential feature of his vocation, the mark of his sincerity?...

Lautrec handled best the everyday quality of the females who sat for him. He made them partake, if one can put it thusly, of the perfect distinction of his art. For some of them it amounted to a rehabilitation through style, the most difficult perhaps, and the least to be expected.

Style, the magic of the artist, the mysterious creation of the mind, is a subject to which one always returns when speaking of this painter. By this indefinable word we clearly intend to convey our admiration of his works, authentic and vigorous, in which life is rendered with broad incisive lines, infused with the character of the great artist himself. This tribute has rightly been paid to him: The enthusiasm and zeal expressed by his countrymen convey a very clear message.

In applying his magnificent talent and fine intelligence to the portrayal of scenes, heroes, and minor figures in the human comedy, Henri de Toulouse-Lautrec has not shown himself unworthy of his name, his birth or his country. His native town, so rich in beauty and in history, today hails him as one who has enriched it with fresh distinction. This spiritual treasure has been put together for the delight of all who from time to time seek to escape the tensions and problems of each day and come to study or admire what survives, what is noteworthy, in this town, this province of ancient fame....

Critical Opinions

The following is a selection of critical appreciations of and comments on Lautrec's work. Two were written on the occasion of his first retrospective exhibition at the Goupil gallery in 1893, while the third is a modern assessment of the artist's achievement.

T*he Princely Idyll.*

Roger Marx Praises Lautrec's Disdain of the Banal

Roger Marx was an influential art critic whose work was published in many journals. With André Marty he founded L'Estampe Originale, *a publication that did much to encourage the revival of lithography, and he also played an important part in the renaissance of the decorative arts at the end of the century.*

ON THE EXHIBITION OF RECENT WORKS BY M. DE TOULOUSE-LAUTREC AND OF M. CHARLES MAURIN, GOUPIL GALLERY, 19 BOULEVARD MONTMARTRE, PARIS

It is a long time since an artist as talented as M. de Toulouse-Lautrec has emerged, and his power derives perhaps from the interaction of his faculties: I mean the combination of his analytic penetration and the acuity of his methods of expression. In his cruel, implacable observation he comes close to [Joris-Karl] Huysmans, [Henry-François] Becque, all those who study the outer physiognomy, the mask, and the inner character of a person. While his artistic methods in the early period might suggest [Jean-Louis] Forain, or [Edgar] Degas, M. de Toulouse-Lautrec quickly broke away from his models in order to develop his own individuality, to become wholly, essentially, himself.

It is interesting to observe in the present exhibition just how true is M. de Toulouse-Lautrec's point of view, his angle of vision; his progress has clearly been constant; his innate talents have developed, increased, in parallel, without interruption; the gifts of the thinker, the satirist, and the gifts of the draftsman, the painter, have arrived at an ever more arresting use of form and

color; but his works of 1887–8 (this female portrait, this theater interior) nonetheless hold the seeds of his artistic output today (women dancing, a scene at a table)….

In summary, Toulouse-Lautrec and Charles Maurin do not come from any school; they do not belong to any clique. The utter independence of their talents, so extremely different from each other, their innate and profound love of drawing, are the only things they have in common that explain why, for a brief moment, their names and works have been linked together.

However short the duration of this exhibition may be, in this age of copies and pastiches we will retain the heartening memory of two talented figures, as disdainful of the banal as of the *déjà vu,* of two proud personalities whose mastery is clearly apparent and strongly asserted.

<div align="right">Roger Marx

Le Rapide, 13 February 1893</div>

"A Lesson in Practical Morality"

Journalist and novelist Gustave Geffroy began his writing career in Georges Clemenceau's paper La Justice. *His collected articles were later published in the eight-volume* La Vie Artistique. *He specialized in the Impressionists, in particular Sisley and Monet, but he also took an interest in the new generation of artists, including Toulouse-Lautrec, whom he first noticed in 1893.*

THE TOULOUSE-LAUTREC EXHIBITION, BOULEVARD MONTMARTRE

Toulouse-Lautrec demonstrates a highly individual style, an artistic approach which develops logically, fueled by a secret inner force. His ability to render "human landscapes" and to put together colors is apparent when one looks at the number of posters he has designed and brilliantly realized; Bruant, La Goulue, and, more recently, the *Divan Japonais* have taken over the streets with an irresistible force. It is impossible to ignore the breadth of line and the artistic power of the magnificent applications of color.

Using varying colors, sometimes rich and subdued, sometimes muddy, almost dirty, according to his subject, Lautrec, painter and pastellist, shows equal skill capturing a figure's sudden appearance, the spontaneity of a gesture or movement, the to and fro of a woman walking, and the whirl of a person waltzing. In each case there is something unexpected in the aspect of life he shows us. This does not lie in the pose, which has been seen before and extensively reproduced; and yet the pose is natural, one of an infinity of natural poses that the artist's keen eye has distinguished from all the others and set before us as a physiological and social comment on life. This art has its traditional aspect, and one can name the serried masters who initiated and practiced it….

There is mockery, cruelty, mixed with complicity in the work of Lautrec, when he is engaged in visiting dance halls, houses of ill repute, and unorthodox establishments. But his artistic integrity rests intact, his pitiless observation captures the beauty of life, and the philosophy of vice which he sometimes displays with a provocative ostentation assumes, in the forcefulness of his drawing, in the seriousness of his analysis, the status of a lesson in practical morality.

<div align="right">Gustave Geffroy

La Justice, 15 February 1893</div>

Lautrec's Achievements

It would be a grave misunderstanding of Lautrec's achievement to see it—as many do—in terms of a successful personality cult. His influence on the future patterns of Western art was cumulatively even more important than the merits of his individual works. Perhaps the most significant contribution he made lies in a field wider than the purely aesthetic, in that no-man's-land between the artist and the general public which might roughly be described as "taste." The massive revolution in art that had been initiated by Impressionism had, by the end of the 19th century, only percolated through to a small section of that comparatively limited section of the general public known as "art lovers." By the popular success of his prints and posters Lautrec created a far greater awareness of the revolutions that had been taking place in the free use of colour, in the emancipation of line and form from a dependence on assumed visual "reality," in the demonstration that a concern for decorative qualities could override a preoccupation with description, and that a work of art could create its own frame of reference. He ignored traditional perspective systems, juxtaposed flat colours, the choice of which was often determined on purely arbitrary grounds, and created anatomical distortions of a kind that would have been ridiculed two or three decades earlier. Yet his creations adorned the streets of Paris, and were seen on theatre programmes, on advertisements and in numerous prints and publications without arousing any of the kind of hostile criticism that was directed against the works of Cézanne or Van Gogh.

He had in fact brought modern art into that realm of mechanical reproduction which had not been widely explored by the great innovators of the immediate past, who even when they did venture into the field of graphics did so without that intense application of the technical aspects of the process which Lautrec cultivated. Even his more "serious" contemporaries such as Vuillard were tentative and unsure when they made excursions into colour lithography. His achievements here too gave an enormous impetus to the whole art of illustration, strengthening its links with painting, and endowing it with a sense of creative self-confidence. A century after his death the influence of Lautrec can be seen still in advertising, in the strip cartoon (notably coloured ones such as *Asterix*) and in the illustrations of science fiction.

The most notable and significant aspect of Lautrec's graphics—still the most popular and widely known of his works—is that they were based on a formidable infrastructure of painting and drawing. It was in his sketchbooks and on his canvases that he defined and re-defined images, from which he pared away visual superfluities to catch the essence of a look, the significance of a stance, and that he experimented with colours, and liberated them, in a way in which the Impressionists had never attempted to do, from any dependence on perceived reality. He was a significant figure in that evolution of Western painting rather roughly described as Post-Impressionism, which in many ways forecast most of the developments in art of the whole of the 20th century.

Bernard Denvir
Toulouse-Lautrec, 1991

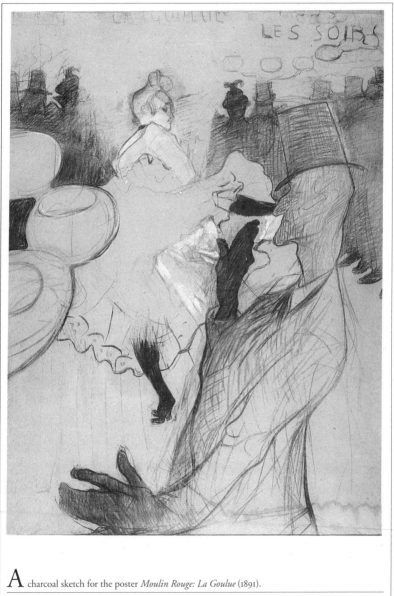

A charcoal sketch for the poster *Moulin Rouge: La Goulue* (1891).

Further Reading

Adhémar, Jean, *Toulouse-Lautrec: His Complete Lithographs and Drypoints,* Harry N. Abrams, New York, 1965

Adriani, Götz, *Toulouse-Lautrec: Complete Graphic Works,* Thames and Hudson, London and New York, 1988

Ash, Russell, *Toulouse-Lautrec: The Complete Posters,* Trafalgar, North Pomfret, Vermont, 1992

Beaute, Georges, *Il y a Cent Ans: Henri de Toulouse-Lautrec,* P. Cailler, Geneva, 1964

Bouret, Jean, *The Life and Work of Toulouse-Lautrec,* Abrams, New York, 1966

Castleman, Riva, ed., *Henri de Toulouse-Lautrec: Images of the 1890s,* Harry N. Abrams, New York, 1985

Cate, Philip D., and Patricia E. Boyer, *The Circle of Toulouse-Lautrec:*

An Exhibition of the Works of the Artist and of His Close Associates, Rutgers University Press, New Brunswick, New Jersey, 1989

Cooper, Douglas, *Toulouse-Lautrec,* Harry N. Abrams, New York, 1983

Coquiot, Gustave, *Henri de Toulouse-Lautrec,* Auguste Blaisot, Paris, 1913

Denvir, Bernard, *Toulouse-Lautrec,* Thames and Hudson, London and New York, 1991

Feinblatt, Ebria, and Bruce Davis, *Toulouse-Lautrec and His Contemporaries: Posters of the Belle Epoque,* Harry N. Abrams, New York, 1986

Frèches, Claire, Anne Roquebert, and Richard Thomson, *Toulouse-Lautrec* (exhibition catalogue), 1991

Frey, Julia, *Biography of Toulouse-Lautrec,* Viking Penguin, New York, 1994

Gauzi, François, *Lautrec et Son Temps,* David Perret, Paris, 1954 (translated by Paul Dinnage as *My Friend Toulouse-Lautrec* in 1957)

Goldschmidt, Lucien, and Herbert D. Schimmel, eds., *Unpublished Correspondence of Henri de Toulouse-Lautrec,* translated by Edward B. Garside, Phaidon Press, London, 1967

Hanson, L. and H., *The Tragic Life of Toulouse-Lautrec,* Random House, New York, 1956

Huisman, Philippe, and Geneviève Dortu, *Lautrec par Lautrec* (*Lautrec by Lautrec*), Edita, Lausanne, 1964

Joyant, Maurice, *Henri de Toulouse-Lautrec,* H. Floury, Paris, 1926–7

Lucie-Smith, Edward, *Toulouse-Lautrec,* Watson-Guptill, New York, 1983

Mack, Gerstle, *Toulouse-Lautrec,* Alfred A. Knopf, New York, 1953

Natanson, Thadée, *Un Henri de Toulouse-Lautrec,* P. Cailler, Geneva, 1951

O'Connor, Patrick, *Nightlife of Paris: The Art of Toulouse-Lautrec,* Universe, New York, 1992

Schimmel, Herbert D., ed., *The Letters of Henri de Toulouse-Lautrec,* Oxford University Press, New York, 1991

Symons, Arthur, *From Toulouse-Lautrec to Rodin* Ayer Co., Salem, New Hampshire, facsimile of a 1930 edition

List of Illustrations

Index

Acknowledgments

Claire and José Frèches particularly thank Anne Roquebert and Richard Thomson, who organized the exhibition "Toulouse-Lautrec" (London and Paris 1991–2), and whose research and advice helped in the production of this book.

Photograph Credits

All rights reserved 14l, 14c, 14r, 127r, back cover. Artephot/Faillet 24b. Artephot/Kumasegawa 122b. Art Institute of Chicago 16–7, 35, 42–3, 45, 52–3. Bibliothèque Nationale, Paris 1, 8, 27, 29, 32r, 36br, 37l, 44b, 46, 47b, 55, 56–7, 57l, 57r, 61, 64, 65, 66, 67, 68, 69, 74ar, 78a, 80l, 80ar, 80br, 81, 83b, 84a, 85l, 90a, 90b, 92b, 93r, 98a, 104, 105a, 106, 107, 108, 110l, 110r, 110–1, 116, 117, 120l, 120r, 123r, 124l, 144, 154, 159, 161, 164, front cover. Boymans van Beuningen Museum, Rotterdam 37r. Bridgeman Art Library, London 42b, 114, J.-L. Charmet, Paris 149, 153. Sirot/Angel Collection, Paris 47a, 49al, 49ac, 49ar, 53, 60r, 74b, 129, 137. Courtauld Institute Galleries, London 72, 112. Edimédia, Paris 7, 41, 87b, 94–5b, 96. Fogg Art Museum, the Harvard University Art Museums, Cambridge, Massachusetts 11, 115. Giraudon, Paris 51. Giraudon/Archives Larousse 109. Giraudon/Bridgeman Art Library 105bl. Giraudon/Lauros 89. Simon and Alan Hartman Collection 21ar. Josefowitz Collection 62r, 75a, 77r, 82, 101a, 103. Los Angeles County Museum of Art 125l. The Metropolitan Museum of Art, New York 105br. Musée de la Publicité, Paris 92a. Musée du Louvre 3. Musée Toulouse-Lautrec, Albi 2, 4, 6, 9, 12, 13, 15l, 15r, 16, 18al, 18ar, 19, 21b, 22, 23l, 26, 31, 36l, 39l, 43r, 46–7, 49b, 59r, 70r, 71r, 76, 77l, 79l, 84b, 86, 88, 91, 93l, 94–5a, 97, 111, 113a, 118al, 118ar, 118b, 122a, 123l, 126–7, 130r, 131, 133, 135, 140, 141, 143, 146, 156, 157, 160, 162, 167. Musée Toulouse-Lautrec, Albi/All rights reserved 16, 23r, 70–1a, 125r. Musée du Vieux Montmartre, Paris 30l, spine. Museu de Arte de São Paulo 98b, 99, 119, 128. Museum of Fine Arts, Houston 87a. Museum of Modern Art, New York 39r, 50. National Gallery of Art, Washington, D.C. 34, 54. Henry and Rose Pearlman Foundation 24a, 25. Philadelphia Museum of Art 5, 48. Private collection 18b, 20, 28, 33l, 40, 44a, 58, 59l, 60l, 61a, 78b, 79r, 83a, 102a, 102b, 121, 124r, 130l, 134. Pushkin Museum, Moscow 75b. Oskar Reinhart Collection, Winterthur 63. Réunion des Musées Nationaux, Paris 3, 62l, 73, 85r, 100–1. Roger-Viollet, Paris 17, 20–1, 56a, 150. Sterling and Francine Clark Art Institute, Williamstown, Massachusetts 38, 113b. Tate Gallery, London 33r. Vincent van Gogh Foundation, Vincent van Gogh Museum, Amsterdam 32a

Text Credits

Grateful acknowledgment is made for use of material from the following works: Bernard Denvir, *Toulouse-Lautrec*, 1991, © 1991 Thames and Hudson Ltd, London. Reprinted by permission of Thames and Hudson Ltd, London (p. 166); *The Letters of Henri de Toulouse-Lautrec*, edited by Herbert D. Schimmel, 1991, © Herbert D. Schimmel, 1991. Reprinted from *The Letters of Henri de Toulouse-Lautrec*, edited by Herbert D. Schimmel (1991) by permission of Oxford University Press (pp. 130–49 and 161); *Unpublished Correspondence of Henri de Toulouse-Lautrec*, edited by Lucien Goldschmidt and Herbert D. Schimmel and translated by Edward B. Garside, 1967; reprinted by permission of Phaidon Press Limited, 1967 (pp. 136, 139, 147–8)

Claire Frèches, a curator at the Musée d'Orsay, was involved
in the foundation of the museum. Joint author of a
number of works about the paintings in its collection,
she organized the exhibitions of Capiello (1981), Gauguin
(1988), and Toulouse-Lautrec (1991). She and Antoine
Terrasse together wrote *The Nabis* (Abrams, 1990).

José Frèches, a native of southwestern France, was
curator of the Musées Nationaux between 1971
and 1975. Now the managing director of an industrial
group, he is a member of the Conseil Artistique of
the Réunion des Musées Nationaux.

Translated from the French by Alexandra Campbell

Editor: Jennifer Stockman
Typographic Designer: Elissa Ichiyasu
Design Assistant: Miko McGinty

Library of Congress Catalog Card Number: 94–70537

ISBN 0–8109–2863–9

Published in 1994 by Harry N. Abrams, Inc., New York
A Times Mirror Company

Printed and bound in Italy by Editoriale Libraria, Trieste